selling
venus

selling
venus

edited by
Cecilia Tan

Circlet Press, Inc.
Boston, MA

Selling Venus
edited by Cecilia Tan

ISBN 1-885865-05-8

Circlet Press, Inc.
PO Box 15143
Boston, MA 02215

For more information about Circlet Press erotic science fiction and fantasy titles, please send a self-addressed stamped envelope to the address above, or contact us at circlet-info@circlet.com (World Wide Web: http://www.circlet.com/circlet/home.html). Retail, wholesale and bulk discounts are available.

Table of Contents

Introduction

I've always been interested in turning things inside out, making things loop back on themselves. Perhaps that's why I like the idea of doing an anthology of erotic fiction on the subject of the sex industry. Technically, this book itself is a part of that industry—the exchange of money for sexual stimulation or gratification, in this case in the form of smut/erotica/porn... Whatever you wish to call it, this is, without a doubt, a book intended to stimulate. The content of the stories *is* intended to get the sex juices flowing. But, for me at least, there is the added intellectual stimulation of the twist—the book is the subject of itself, the medium is the message, and the message is not as simple as it seems.

We begin with a story about the act of writing smut itself, with Thomas Roche's "Temporary Insanity," about two forms of "prostitution" that struggling writers often find themselves tempted with: writing hack porn novels, and taking a "temp" office job for an hourly wage.

From there we venture into the hardcore realms of actual sex with a series of stories in which the object of lust (the whore) is equated with machines. But these are not mere stroke stories about johns who pay for the perfect fuck—inhumanly perfect physical features, says nothing but good things about his dick size? No. Jim Lee's "Service Stop" seems like a light tale about a sex robot repair service with good nookie on the way. But look at why they have to make this particular service stop—the sex robot in question has tried to take her destiny into her own hands in a drastic way. In Doug Tierney's "The Portable

Girlfriend" our artificial intelligence VR babe uses her formidable intellectual resources when our hero's seems unable to. In M. Christian's "State" we have a real live woman playing the part of a sex robot for her living, as she struggles to define her own destiny, and in Renee Charles' "Like A Reflection..." we have a woman whose experiences with a particular brand of high tech sex, rather than making her more machine-like, in the end make her more human as she realizes the power she has. In every story, the woman, be she real live flesh or machine consciousness, struggles to gain control of her destiny and in one way or the other succeeds.

Evan Hollander explores the other side of the coin with "Chance Encounters." Now it is the john who has to gain control of his sexual life, in a world where he must struggle to define himself in the face of low self-esteem and unpopularity. What is going on here? It seems that our authors have something more to say than what anti-pornography adherents would have us think. Men are *not* content to keep women as objects nor are women content to be kept as such, and real fulfillment comes not with orgasm, but with control of one's own life.

The volume ends with a trio of stories in the realm of illusions—the movies. In Melanie Fletcher's "Star Quality" the brightest stars of Hollywood films (perhaps our world's most sophisticated kind of whoring...?) struggle to keep control of their own identities while they must play roles on and off screen. In Yvonne Navarro's "Touch Me" the star of a porn production company finds she may be losing control of her body in a most peculiar fashion. And in Jarrett Trane's "I Think I Scan" our star, who has no qualms about exposing his genitalia or his innermost thoughts to the rapt audience for high-tech porn "scans," finds himself exploited in a very different way. Again, there are twists, as the themes double back on themselves and become meta-themes. And once again the underlying central issue is self-determination.

When I set out to collect these stories, my main concern was that they be deliciously, lasciviously, hot. I did not ask for any kind of political statements, pro or con, about the sex industry. And in fact, none of these stories presents a moral. These stories subtly imply, through their humor, their moving characterizations, their dripping wet sex scenes, that the human condition is always a struggle for self-determination, and at this intersection of sex and commerce we can see the struggle especially well.

Perhaps it is a larger comment on our society, a culture in which sex and sexuality are so very tightly controlled, by overgrown mores, by governmental laws, by the decrees of organized religions... it seems everyone wants a say in how we should and will have sex. The media and advertising push images of what ought to be considered sexy. The governments of many states enforce their sodomy laws, trying to dictate what consenting adults can and cannot do in the privacy of their own bedrooms. Then there is the growing anti-pornography lobby (which will likely keep this book out of Canada, where two of the authors reside, regardless of whether Canadian customs ultimately approves or disapproves of its content). So here we twist back on ourselves again. This book *is* porn, and this book is about porn, not just in the subject matter of the stories, but in the underlying message that it is in the arena of sex that the front-line battle for personal freedom is being waged. And if we want to be able to enjoy good sex, guilt-free (and good porn) it is a battle we must win.

But I don't have to tell you that. You're already doing your part for sexual freedom and fulfillment by reading this book. So, may you find it freeing and fulfilling!

Cecilia Tan
May 1995

Temporary Insanity
Thomas S. Roche

I lived in health clubs among glittering mirrors and dropped by mansions when I wanted to relax. I posed for a trillion nude photos, a skin flick slut seduced by the photographer—and generally his or her assistant(s)—at every shoot.

I lost my virginity a thousand times, spread like succulent marmalade on canopied king-sized beds, tangled in satin sheets and caressed by baby oil and vibro-fingers massage. I did red hot virgins whose need consumed them. I took on cruising bimbos three at a time. I seduced the neighbors (all of them) while my husband was at work, sunbathed nude twenty-four hours a day, owned two thousand black garter belts and a million pairs of fishnet stockings, eighty leather jock straps, a hundred split-crotch panties and forty thousand pushup bras. I had a fifty foot cock and a pair of hundred pound tits. I invariably deep-throated on the first try, and juices were constantly running down my thigh. I went to a tanning salon at eight, noon, six, and midnight, serviced each time by the helpful massage therapists in their skintight tank tops and nylon gym shorts.

I haunted bars replete with domestic cigarettes and hard alcohol, a cocktail waitress who didn't own underwear. I was, perpetually, a freshman in college with enormous breasts and/or blonde pubic hair. I spent most of my time in Southern California, occasionally dropping by Hawaii for the weekend. I was going for my PhD in Sexology and used this as an excuse to seduce every hot

young stud and flirtatious virgin in my class. I used my position as CEO of an enormous corporation to get me pussy. I drove around pedal-to-the-metal in Daddy's Porsche 911 convertible, cruising for hot young flesh.

I was badder than Satan. I turned out porn novels faster than a printing press turns out wedding invitations. I ate latex double-headed dildos at sundown and shit tiger-striped nylon jock straps just before dawn. I pissed French Roast and slept with my boots on.

I was the god(dess) of Sleaze, the Damned Thing, the Pornographer, a vision of Sex with its tits on backwards.

I had a stack of published porn novels twice the size of my roommate, all with my name on them (or someone else's, I forget whose). Half again that many books were in transit awaiting publication. I was paying the rent. Nothing could touch me.

The publishing house I had been writing for had gone out of business, taking several of my porn novels with it before I knew what was happening. I was left with a credit-card balance approaching infinity and a stack of unpublished pornography that was now almost worthless. I was in the death-grip of capitalism, and the end of the month was approaching.

I got wind of a shady outfit in Brooklyn that published original novels, hardcore S/M she-male and bestiality books for an absurdly low fee provided you sent it on disk so they didn't have to retype it. I could not work for such shitty wages, and resolved to starve rather than prostitute myself thus.

It was thus that I submitted, with a sick, curious pleasure, to the ultimate degradation beneath the booted feet of the System.

I submitted myself, wrists crossed, to temporary insanity.

So it was that I came to stand before the dark tower,

dildo in one hand, begging bowl in the other, tie loosely knotted, to the foot of the forty-story building to answer phones for $12.50 an hour. I was greeted by a middle-aged woman with a frilly white shirt and a wool blazer with an "I LOVE SF" button on it. Her name was Deirdre. She led me through miles of winding cubicles, under fluorescent lights, through the valley of the damned. I was not afraid. She spoke to me about the duties I would be fulfilling, but she seemed to be speaking ancient Greek.

Finally, we reached my cubicle, deep in the belly of the beast. There was a Garfield doll hanging from the light fixture, and a computer in one corner of the tiny cubicle.

"Susanne is on vacation," Deirdre told me. "She normally answers this phone. People will be calling in if they have problems on the network. They'll get put on hold in a queue at the service desk. If they want to speak to someone immediately, they hit the pound key, and they'll be transferred to you."

"And what do I do with them?"

With a straight face, she told me: "Ask them to wait a moment, and transfer them to the service desk."

The hum of the fluorescent lighting grew in volume until it filled my entire being. The phone had not rung at all. The boredom was like a fine espresso or a cigarette I savored but did not enjoy. The minutes grew exponentially longer. 11:23 lasted for eight years.

My tie seemed to be choking me. The polyester pants, all I could afford on such short notice, was a field of ants crawling over my balls.

I stared at the black computer screen.

I couldn't. I wouldn't. It was crazy.

Tentatively, I switched the Damned Thing on.

Around four, Deirdre dropped by to make sure I was doing OK. I quickly switched screens and sat there grinning nervously.

She regarded me as if I were a maniac. Her gaze gradually softened, and her lips parted slightly. I noticed that her tits had gotten larger, her eyes bigger and more seductive. Her gray-streaked hair was now bleached, teased in an inviting mane of an unearthly color. She breathed deeply, her breasts heaving, as she sat on the arm of my chair.

Deirdre's palm grazed my cheek as she gazed into my eyes. Her own baby-blues were shaded by mascara-black palm fronds.

She spoke in a low, harsh whisper.

"How is the day going?"

"Fine," I mumbled.

"Do you have any...questions?"

"Sure," I mumbled. "Do...uh...do you need me back tomorrow?"

"Oh," she sighed. "We couldn't do without you. We need you back for the rest of the week. Susanne doesn't come back until next Monday. You're doing great. Everybody here likes you."

I was a bit confused, since I couldn't recall having met anyone, but I let it slide. "You can go ahead and pack up to go home," said Deirdre. "We don't get many support calls in the last hour of the day, so just go ahead and leave at five...."

I didn't have the heart to tell her that I hadn't gotten a single call all day, except for a wrong number around noon.

After she left, dancing in perfume and hallucination her way out of the cubicle, I turned my attention back to my computer, and the novel in progress that lay within.

I was the she-male, an androgyne with a flawless pair of silicons and a foot long schlong undamaged by hormones. I was a creature of desire.

I cursed. I hadn't brought any floppy disks, and there were none to be found in the office. Chapters One and Two, where the she-male in question visits a weight room and thereafter an ice skating rink, were on the hard drive.

There was nothing that could be done, so I secured the files, turned off the computer, and left.

All night long, I was tormented by visions of some perverted hacker working his way into the office in the middle of the night and feeding random combinations to the word processor until he found the password to those files.

But when I arrived the next day, the two chapters were still there, intact, and the hair I'd placed on the keyboard was on the same place. Some people tell me I read too many spy novels.

I went back to work. There were a lot of calls that day, particularly during the particularly steamy scene involving the she-male and a kitchen full of pastry chefs wearing nothing but aprons that said "KISS THE COOK."

The phone rang like an avalanche of Tibetan wind chimes.

"Hello," I mumbled incoherently, sweat pouring down my back and soaking my undershirt. "I mean...Technical Support, can I help you?"

"I can't get my machine running," the young woman on the other end of the line said breathlessly. "It seems to be giving me error messages. Do you think it might be going down?"

I had to think about that one. "If you'll hold for a moment, Ma'am, I'll transfer you to the service desk."

"I don't want to be transferred to the service desk. I want you to help me." It was said with husky, breathless desperation.

"Can you hold?"

"Oh...I guess so."

I transferred her away into nothingness and went back to Chapter 4, introducing a phone call on the kitchen phone from a woman desperate with need. The she-male invited her over and the bread was effectively kneaded while the chefs kept doubly busy on biscotti with unusual shapes.

The she-male finished off with the pastry chefs, leaving them caked with flour, spread out across the kneading table.

The phone rang again.

It was a panting, desperate being of questionable gender, but the voice was rough and whispered. "My terminal tells me access denied, but I know the password's right. I need to get in. I need in, right now—open up? Please open up and let me in? I want to enter...at the highest possible baud rate...open up! Open up for me, She-male!"

I frowned. I seemed to be suffering from intermittent hallucinations, something numerous colleagues of mine had experienced. I shrugged.

"If you'll hold a moment, Ma'am?"

"That's 'Sir' to you, punk! On your knees and give me access! On your knees, She-male, and take my data stream right into that steaming hole!"

Things had gotten serious.

"Hold please," I said. "I have a hallucination on my other extension." I transferred him away. "Technical support," I said to the next caller.

He responded with a desperate plea. "Need it! Want it! Gotta have it! Help me get it running! I need my access! Lines closed up! Need them opened! Please! Please! Open me up—wide!"

"Oh shit," I said. "Let me get you the service desk."

"No, oh God, please," he wailed, his voice crumbling into a dancing desperate moan. "Not the service desk— they're limp-dicked pansies! I need you! I need the she-male! Bring me back on-line!"

"Holy fuck," I muttered. "Hold on a minute."

I transferred him.

Again and again, three lines at once.

"She-male! Fuck my tits and help me reestablish my carrier!"

"Jesus Christ. Uh....wait a minute...hold please...."

"Oh God! Fucking oh my fucking God, She-male, put

those luscious lips together and give me the 800-number for 9600 baud access, now! I need it now...oh please give me the number..."

"Um, excuse me, but you'll have to wait...holy fuck..."

"Swallow it! Swallow it, baby, and cough up the terminal type, cough it right into my ear, baby, I need it!"

"Shit!"

"I'm sitting here naked at my terminal, she-male, and I've got my cat in my lap. I want you to put that collar on and meow like you've never meowed before..."

"Oh son of a bitch...hold please..." There was nothing to be done. The calls would keep coming until She-male gave in to the desire of the callers and became their eager-dreaming pleasure pumpkin.

"Let me swallow your hardware...let me tongue your software..."

The she-male laid her bed of satin sheets and switched to speaker phone.

At the end of the week Deirdre signed my time sheet with a puckered red kiss of her blackberry-slathered lips across the words "Supervisor Signature," and with a friendly wave bid me farewell.

I carried home the better part of "She-male Software Slut" secreted away deep in my valise among ancient Guardians and dog-eared Paul Bowles novels.

I finished the novel sitting at my computer at home playing Lydia Lunch's "In Limbo" at top volume. Her erotic moans evoked the desperate hallucinatory dreams of people trying to reestablish their carrier.

She-male ended up in a villa in Switzerland, sharing it with three dozen nuns, two Russian construction workers and a German Shepherd.

I sold the novel, all rights, to the aforementioned shady outfit in Brooklyn for the colossal sum of $200. That roughly approximates the $1 a page that Henry Miller made some half-century ago. I started work on something a little slower-paced.

One morning after working all night I walked a mile or so to the edge of North America and watched the sun rise like an acetylene holocaust over the Golden Gate Bridge. Sea-birds screamed their war cries far beneath me as I chain smoked Pall-Malls at the crumbling edge of the cliff.

The fluorescent sun rises above acres of cubicles with faceless pimpled creatures laboring pathetically and dancing their unmoving death-dance here at the frozen moment of the forty-story apocalypse. I thought about that and smiled.

I had danced for real.

A demon wind sprang up from the ocean and put out my cigarette.

Service Stop
Jim Lee

It looked like yet another slow afternoon at the Android Service Center. Roberto Clemente Nichols sighed and reached for his Virtual Reality training hood.

Nichols appreciated the status he had as a Repair Tech at the top-rated Center in their Zone. The money was good. He liked his work-partner, even got to hump her occasionally. And the work, when it presented itself, was often quite challenging. Exciting, almost like being a doctor—except that his 'patients' were sick or injured machines, built to more-or-less resemble human beings. But the slack periods threatened to drive him crazy. He was a man of action and seldom allowed himself to relax. So he donned his VR hood to pass the time constructively— reviewing the most esoteric repair procedures he might face on the new GUS-620 series.

Another man might have taken the not-too-subtle hints his work-partner had been dropping and slapped groins with her a while. But they were still on Company Time and Nichols took that kind of thing more seriously.

He was just that kind of guy.

Besides, he told himself as he called up the simulation for the fourth time, these 620s are really something! They were at least a full order of magnitude more capable than the 3-year-old 610 models, right across the board. Nothing less than a revolution in the field of General Utility Servomechs. With the increased capabilities came at least an equal jump in operational complexity. Whole new sets of processing relays and interaction nodes and dynamic interfaces for Techs like Nichols to get familiar with. Worse,

systems as advanced as the GUS- 620 eventually developed quirks—individual variations that all the Design Engineers claimed were impossible and which went well beyond differences in the data inputs each unit received. Androids—machines with unique, actual personalities?

Of course the Design Engineers said no, it was not possible. Said it as loudly and as often as they could.

But Repair Techs like Roberto Nichols knew better. His 'patients' were getting more alive, more self-aware—more human!—with each passing year.

Nichols shook his head, concentrated on the simulation. This computer-generated Reality was strictly for training purposes. So it included Nichols himself, his tools, a disabled 620 unit, the table the Droid was sprawled upon and not much else. Certainly no cheery background images to distract the eye; no sounds or smells or other sensations that did not strictly belong in such a pure-work environment.

Nichols was startled when someone suddenly appeared at his elbow and stuck a warm, wet tip of a tongue in his ear. He jerked, ruining the circuit pathway splice he'd been running up the back of the 620's left leg strut, just below the knee.

"Dori!" he growled, flicking the laser connector off and placing it on the table before turning. He knew it was his work-partner, Doreen Hotchkiss, even before the Virtual tool's faint throb was out of his hand. Her erotic, teasing giggle was unmistakable. Besides, nobody else would dare violate his privacy in quite that way.

Nichols snapped his head around to deliver a stinging comment as soon as they were eye-to-eye. But then he saw that she was bottomless—no shoes, socks or pants. No panties, either, but Dori seldom bothered with underwear in any case.

She winked, showed him all her teeth and turned his hip with a confident hand. That hand moved to the sealing strip that held his spotless, cream-colored uniform pants

shut. She massaged his crotch with a pressing palm and fluttering, expert fingers.

His eyes dropped and she abruptly turned her pelvis, grinning and shaking her mostly-blond head. But he'd caught a fleeting glimmer of reflected light and heard the soft tinklings from between her legs. She kept her hip to him, not allowing him to see. But it wasn't hard to guess.

"Bought yourself some new crotch jewelry?" he said. If it was something he'd seen before, she wouldn't have ruined his training session. Dori Hotchkiss was young and horny, loved all types of erotic play. But she was also a capable Tech and had her own, slightly peculiar, personal rules.

I know her, Nichols reflected. Almost too damn well!

"You'll have to come out to see," Hotchkiss purred. For a second it looked like she might flex her shoulders, make her rounded tits wobble behind her pullover top as further enticement. But she didn't bother. Dori knew him pretty well, too. Instead, she let her mouth hang open a bit after licking her glossy, zebra-striped lips. She withdrew her hand from him and swept it up her torso. Her image winked out of Virtual Space the moment she dislodged her unseen VR hood.

Her work-partner stood rigid for a full minute. He was, he judged, about due for a break. And something was definitely stirring in his pants. But he didn't want Dori to think she had total control over things. So he waited another couple seconds, idly arranging his Virtual tools into a neat row between the sexless GUS unit's silver legs.

"Okay," Nichols said aloud and he peeled his hood off with a flourish. He blinked, his eyes taking the required moment to get used to the harsher light of the real world. Then he took three measured steps, put his VR hood back in place on the wall and paused to smooth the wrinkles out of Dori's on the next peg over.

He heard her eager snort and turned, raised his eyes until he saw her on the empty upper shelf of the distant work station. Her knees were bent up in front of her and parted,

her toes thrust out beyond the shelf about level with his chest. She still wore nothing but her Company sweater, but her arms were folded together atop her knees and she hid part of her smirking face behind them.

The one eye Nichols could see winked at him and the part of her mouth he could see wriggled open for another giggle. "You wanna see or not?" she taunted.

He moved to her and waited as she shifted her feet, turned her toes outward. Her slim butt came off the dust-resistant synthewood surface and gave him an unobstructed view.

The jewelry was clipped carefully to a trio of contact points, forming a shiny triangle around her partially erect clit. Stimulating her with faint, randomized bio-electric pulses—so that every second she wore the clips her pleasure nub was (at a minimum) in a state of warm semi-arousal.

From the contact points dangled three strands of spun-metal, one each of silver, gold and platinum. Neutron bombardment and other, even more exotic processes, left the metals soft and flexible. Each strand was embedded with tiny, odd stones from the mines of Ganymede, Jupiter's largest moon.

Nichols knew they were genuine—the cheap, synthetic knockoffs crafted in Europe and at the New Liberty Orbital Colony simply weren't her style.

And speaking of style, she'd been redoing her crotch area again. To his relief, Nichols saw her lengthy, narrow slit itself was unchanged. But her shorthairs were now bunched and cut in a parallel set of zigzags, one to either side of her pussy. Each shift in direction signaled a new color. Along with the natural, slightly tarnished golden hue, her cunthair now featured segments of burnt ochre, green-brown haze, Neptune blue and tangerine—in short, all the flamboyant tints the fashionable Hotchkiss already had streaked through the again-popular pageboy cut on her head.

Nichols swallowed hard, put his hand out. He made a game of jiggling his fingers between he spun-metal strands while causing the absolute minimum vibrations. He knew every time the strands were disturbed it caused subtle, exciting variations in the contact points' firing pattern. Besides, he thought, Dori had earned some serious teasing.

She shivered, her pussy rotating in slow circles, the thin folds visibly moist. Dori gasped and put her head back when his fingertips finally met her anxious flesh. She moaned his name—"Roberto! Oh, Roberto!"—as he stroked her labia. Then, just as he was about to answer her pleading, as he slowly pushed three of his fingers into the waiting, aromatic wetness of his work-partner's sex— Assignment Droid 27 rolled to Nichols's side and whistled for attention.

Christ! Nichols thought. Then he threw in Buddha, Allah and Erica Jong for good measure. This was definitely his day for interruptions!

"Repair Technician Nichols," the stuffy machine said. "You and Repair Technician Hotchkiss are required for an immediate home service stop. Mr. Faust Killian, the zillion-aire data management tycoon, reports complete system failure of his Dedicated Love Droid. Priority Level 5."

"Oh, fuck," Hotchkiss muttered with disgust. "Okay, come on Robbie—finish me up quick!"

Assignment Droid 27 swiveled and elevated its main visual sensors. "No time for that Repair Technician. Kindly release your work-partner's fingertips and return to Company-approved clothing for immediate departure."

Defiantly, Hotchkiss flexed her vaginal muscles. "First I get-off, then we get to business!"

Nichols enjoyed the rhythmic sucking action of Dori's well-trained cunt, but this sounded like a bigtime job. He gestured with his free hand. "Okay, if you insist. A.D., Special Order 408—engage!"

Obediently, a pencil-thin telescoping appendage sprang from the Droid's main section. It moved with speed and

precision to Dori Hotchkiss's crotch. The tip flattened when within striking distance and met her suddenly rock-hard clit, imparting a bio-electric nerve shock maybe 200 times as intense as the crotch jewelry could generate.

It was perfectly safe. But strong enough that Nichols, his fingertips still inside her to the first joint of each digit, felt a sudden tingling sensation.

Dori threw her head back. The rest of her body went rigid. Her cunt clamped down on Nichols's fingers so deliciously it almost hurt. She let a cry—a sharp, high-pitched yelp of surprise. And satisfaction.

Breathing rapidly, she relaxed.

The Droid's appendage pulled back and Nichols regained his freedom, licking his fingertips and grinning before accepting the mission specs from the Assignment Droid.

"Back into your pants now, Technician Hotchkiss."

"Fuck you," she sniffed at the machine. The Droid started to comment that was outside its programming, Special Order 408 notwithstanding. But Dori jumped to the floor, grabbed her pants and stepped into them. She let the sealing strip close, half-molecules binding neatly to their mates, not even leaving a visible seam in front of her pleasantly throbbing crotch.

Nichols laughed and grabbed his toolbelt. Hotchkiss snagged hers, donned her shoes and socks, then followed her work-partner to the transport area.

An aircar was waiting, its autopilot programmed.

Faust Killian was a real big deal—maybe the richest man on Earth, fifth or sixth richest in the entire Solar System. You had to be rich, to own a Dedicated Love Droid for personal use. The electronic bordellos had plenty of them, of course. But who had an Android in his home whose one and only function was to provide sexual pleasure? And for that matter, who had the money for a one-of-a-kind, custom-built unit? Faust Killian, that's who.

Nichols and Hotchkiss ran the specs through a viewer

in the backseat. The Droid's inner circuitry was so damned complex, even Dori was too busy studying them to get funky.

The Killian mansion was famous and justly so. But the Great Man himself let them in, as soon as they cleared Security. Killian was redfaced, in a purple robe he'd obviously just thrown on and never bothered to close. Nichols noticed the robe had genuine buttons instead of a sealing strip—which made it an antique. He was willing to bet the fabric was real silk, too.

His partner was more interested to note that behind Killian's robe, the zillionaire was completely nude. Not shy about it, either. Killian led them up an ornate staircase, babbling that they had to do something—anything!—to save his Selena.

"He calls her Selena," Nichols muttered.

"Selena the Sex Droid," Hotchkiss gasped, barely holding back a giggle.

But then they followed Killian into what had to be his bedroom and they fell totally, respectfully silent.

Everything in sight was priceless. But it all paled, next to her.

Sprawled with limp grace almost sideways on the 4-poster canopy bed, her lustrous perfection even now put the rumbled, bright red satin under her to shame. Her long, thick hair was straight, and so real it made you yearn to sniff it. Dark brown, mostly, but with just the most subtle hint of a lighter shade of auburn blended in on one side. Her face was beyond gorgeous—a rounded delight of a jawline, a long yet indisputably appropriate nose, cherry lips just to the more believable side of bee-stung. And those eyes—exciting, captivating even in their present, lifelessly unfocused state.

What must those be like, returned to working order? Nichols shivered, caught Hotchkiss doing the same.

The rest of her was just as impressive and, with an audible gulp, Nichols realized why. Even the most advanced

Droids, the ones who seemed the most human when operating, reverted to no more than beautifully crafted devices when shutdown. You could again convince yourself that it was, yes indeed, an 'it'—the apparent gender mere styling, with no truly, fully human soul in residence within. But not with this one! She was "she," not an "it." She was— Selena.

Nichols and his partner bent over, stroked the cool, unresponsive body. They both looked up, met Killian's guilty eyes.

"She's more than a machine," Nichols said.

"Yes," Killian whimpered, bobbing his head.

"You love her."

"Yes."

"And you know what caused this?" Hotchkiss added, taking her scanner from her belt.

Killian froze, staring at the inert beauty. He mumbled, then gasped a confession. "It's all my fault! I had her designed as a Dedicated Love Droid—the entire fiber of her being is in giving and receiving sexual attention! It's all she knows, all she desires! But I also had her brain developed to the maximum, to keep me interested. All the best programming."

"You found she had needs you couldn't satisfy?" Nichols guessed.

Killian gave another, fitful nod. "The Love Droids at the bordellos, they get fucked what?—ten, twelve times a day?" Nichols shrugged, Killian shook his head an continued. "I'm just one man!"

"But you could let your friends..."

"No!" Killian snarled. "I was too selfish! I—I loved her and wanted her all to myself. It finally got to be too much for her to stand. She said I'd be sorry. But I never thought she'd..."

"Overload a dozen of her internal relays, intentionally!" Hotchkiss exclaimed, handing Nichols her scanner.

Nichols ran the data, got the same conclusion. "A

suicidal Android," he muttered with dismay.

"Suicide," Killian repeated. "And all my fault. You've got to repair her!"

"We can," Nichols said. "And we will, of course. But before we're finished, you'd better make some hard decisions. If nothing's changed, she's likely to try again. And maybe next time, it won't be something we can put back together!"

Solemn, Faust Killian drew himself up straight and nodded. He looked away, unable to stand the sight of the Techs opening access ports in his lover's torso and neck, affixing electrodes and repairing, replacing damaged relays. It was like watching them perform surgery on your spouse, right there in front of you!

And then, at last, it was over. Nichols came up to Killian's elbow, told him she would activate the instant the last access port was magnetically sealed.

"I'm ready," the zillionaire said, turning to watch Hotchkiss run a handheld probe over Selena's exquisite abdomen. A crack no more prominent than an old-fashioned appendix scar closed in response.

The Love Droid blinked, scrambled up on one elbow. She seemed both afraid and excited by the presence of two strangers with her and Killian in the bedroom. Her eyes were piercing and hot, going from Nichols to Hotchkiss and back again, reacting strongly to the comforting stroking of her hands.

"Faust?" she asked, her voice as luscious as the rest of her.

"These are the Repair Techs, darling." Killian reached out, raised her foot and kissed it. He nuzzled her ankle gratefully. "We'll do it your way, from now on. You can have all the fucking, all the sucking you need! Hell, I'll hire Sexualists—of every sex and type, if you want—and see you're happy, whatever the cost! As long as you only truly love me and never pull another stunt like this again!"

Selena's smile was electric. She sat up straight, untied

the front of her lace-trimmed push-up bra as she swore she could never in a billion years love anyone but Faust Killian. Oh, she could and would fuck others—and gladly, too! It was what she was built for, after all. But love—that was just between the two of them.

Nichols and his partner both sighed when the bra fell away. Selena's full-nippled, 40-DD tits sagged the way a real woman's would, a detail too often missing in your average Love Droid. They both stared in envy as Killian dove forward and buried his face in that luscious, faintly tan-lined cleavage. Nichols signalled Hotchkiss it was time to go and both rose from the bed, reluctantly.

That was when Selena reached out, seized them both by the wrists. "Darling?" she spoke to Killian while shifting her compelling gaze between the other two. "I'd like these two to be my first pure fucks! Can they join us? Can I thank them both properly, for giving me back my life?"

Killian pried his sucking lips from her nipple at last and smiled, kissed her and laughed. "Anything that makes you happy, baby!"

Selena insisted on stripping all three of them—Killian, Hotchkiss and Nichols—completely naked, one by one. Then she kissed and licked them slowly, until all three were frantic with desire.

Dori Hotchkiss wrapped her legs around Selena's throat, wriggled delightedly against the Love Droid's wide mouth and long, thrusting tongue. Killian held one of Selena's legs in the air and stared joyfully down at her tits, which jumped and rocked with every thrust he took, deep in her cunt. And Roberto Clemente Nichols got down on his side behind her, parted a creamy pair of fleshtoned buttocks. He dick was long and thick and very hard. But every millimeter of it slowly, relentlessly went up the Love Droid's snug, synthetic rectum.

That was the first of many wonderful combinations and a good time was, as they say, had by all—human and otherwise.

state
M. Christian

The building floated on Kyushu harbor. Once part of a sprawl of temporary industrial units meant for a Korean-owned nanochip factory, now forgotten like an obsolete power tool, it had been stuck on a shelf and left to rust. As far as Fields knew—and could see—rust still really managed the property. Rumor said that Mama had scored the old building for cheap and found some hungry jacks to scalp juice from the main grid. And the girls? They came from wherever lost girls always came from: the cramps of hunger or addiction, the Devil of father. They came and Mama fed them, sprayed them when they were sick, and put that rusting roof over their heads. In return, they worked.

Friday nights weren't usually so busy. Tonight there were rumbles from Mama's office that Fields might be called down from her box to work the cribs with the pie-faced girls. But someone asked for the special of the house so she was spared watching the ordinary flatscreen with the rest of the girls. She *was* the special, so she had a while to get ready, time enough to watch the end of *Don't Drop It* (her favorite) on the antique Hakati tank—and *yum!*—relish the show's new host.

The Hakati took a long time to power-down, and she felt that thrill-tingle of worry that some client would come in and see the spray/wash/float of green/blue/red hanging in front of the cheap holo print of *Tokyo At Night* that hid the unit and would ponder a bit too long over why a Mitsui Automaton was watching a game show.

The streets, and common knowledge, said that Autos

took a while to power up, boot up their software, get their circuits warm and ready—though never really willing: the perfect love doll. The perfect toy. The real fact was that it took Fields time to get completely into her Act.

Her friendly gray robe went first, into the hidden closet behind the false wall of phony blinking tell-tales and dummy flatscreens playing loops of technical gibberish. The robe hung on a hook next to the rest of her reality: vid discs, street clothes, wigs, pills, towels, creams, sprays, and plain-faced bottles of special dye.

Very special dye, she applied the binding polymer each morning. Incredibly durable stuff, but she always examined every inch of herself in a roll-up plastic mirror, lathering on the thick blueness at the faintest signs of her real pinkness, before the light over the door flashed green. Her hair, every brown strand, was months gone—and kept at an imperceptible level by a chilling spray of tailored enzymes. Sure, she could wear any of her wigs, and sometimes did for those who couldn't handle a too-inhuman Automaton, but for the most part she liked going smooth and streamlined: they paid for the machine. And her little yellow hexagon pills had about another two hours to go— her skin texture and temperature would be just that different. Not quite human, but almost machine synthetic. Anyone, of course, who knew the real Mitsui would know the reality of pink skin-and-blood Fields under the blue, behind the contacts, beyond the re-engineered body. But then the Autos were very rare, their legends and rumors huge, and who would know the real thing in the dim shadows of big, sprawling, bad Kyushu?

Fields' body was a gift from Mama, really an investment: those long days two years ago with the Osaka Scalpers had taken what nature had lucked her with and shaped her into an almost perfect Auto Class B—still one of Mitsui's most popular models. Strong shoulders, round face with high, almost too-wide-for-nature cheekbones, tiny, pert, full lips, huge crystal blue eyes, high, wide and

moderate tits, huge against her small frame, with aggressively large nipples—some of it was really hers, some was machine made for her machine act. Her looks, real or made, would be good and profitable as long as the real unit was State-of-the-Art . . and the rumors of how good, and how hot, kept flying.

Fields' cortical jack was a gift from Sammi, now long gone. His gift of matched wetdreams through cheap Kobe scalp implants was also gone, one quick brain-trip with the tall and lean New Tokyo hustler had been enough for the pre-teen Fields—spasms of her riding him, his impression of nothing-but-sex nothing-but-sex and her always on fucking top running/stomping all over her images of that one time, that one good time, at that Osaka shrimp stick stand when he had just smiled at her oh so special. The jack was the one and only thing that really remained of him. It was important to the Act, so she kept it polished and in good repair. The clients knew, if they knew anything, that no one had shrunk the hardware for the Autos enough for them to be self-supporting. They expected and got her—Regulation Blue, hairless, eyes also blue but without irises, slightly cool, perfect little ass, perfection tits, and trailing her braid of cables: a love-doll lifted from a Japanese collective consciousness, a manga sex-toy—all eyes and ass and tits and mouth and cunt. Pure fantasy, rolled off the assembly line to a male libido's factory specs. Her body was flesh, tricked by drugs and chemicals—the jack on the crown of her head was real, the line was dead, but she was still State: the perfect whore, the perfect trick, perfect in her Act.

And, god knew, she liked it. Like it a lot—

The tank's fountain of basic colors died, and with it Fields' ritualistic fear of discovery. She sat on the stool, made sure one last time that she was jacked into the dead line, and that her breathing was cool and calculated. Mama buzzed her as she was supposed to, that the client was coming up the stairs.

Green light over the door.

He was nice. She had been there, in that maze of old modular sheeting and drop-in offices, long enough to know it. That night, that Friday, she was tingling with work lust, and she liked it. *Don't Drop It* had that great new host, the one that rang of Sammi, her Tokyo hustler, when he was cruising and straight, and she had enjoyed a quick little jill while watching—running a blue finger up and down her little blue slit, bathing her blue pearl with her own juice. No cry, no come, not enough time for that. But a trembling thrill up and down her, up from her blue pussy, vibrating her back and jigging her leg. She was wet for the client, always wet for him (Mama schooling), but she was going to be really wet for this one.

And he was going to be a good one. Mama school and her years there clicked through her as he opened the door and came in. Shy and kind of reserved. He looked everywhere but where she sat on her stool in all her blueness, the Act full blown: a square room, walled with semi-transparent white plastic, bare save for the stool, a simple futon, one wall the brains of the Mitsui Automaton (closet, bathroom, etc.), and the "Unit" itself sitting on that black and chrome stool waiting for the Job—almost lifeless, almost perfectly human (Regulation Blue, so if they should impossibly break free they could never pass), waiting to do just what you wanted. Anything. At all. Your heart's desire, your cock's (and sometimes clit's) desire.

She stood up and took a neutral position, making sure her legs were just-so parted enough so he could see her blue slit and the dot of her blue clit. Her nipples were hard from her near-jill and Mama school, and she knew her scent was filling his nostrils. Perfectly lifelike. Perfect imitation of a machine that was supposed to be better-than-lifelike.

He was a surprise. A type, but still a surprise. Away from the Company tour, maybe? Shy and inside about this, maybe not wanting to be seen with the rest of his Contacts

diving into perfumed pools and being given tepid blow-jobs by bored/hungry girls? What better way to do the same without the examining eyes: find someone who didn't care, who couldn't shoot him down with a bat of dull, professional eyes.

"Stand up and come here." Stone, gravelly, deep. Young, yeah, but childish, no way.

As Fields stood and walked, in that special loose-hipped caricature that the Autos walked, she took better stock of Johnny. He was youngish, maybe mid-thirties. His synthetic suit was simple and professional. The tie, though, was real silk and the scenario changed. And the tone, the strength, the gravel: maybe he was one of the managers, out to do something special with someone who couldn't complain or say no... to anything.

She didn't believe it possible, but Fields got wetter. She liked it rough and fast and maybe metal-tinged dangerous when she liked it. And she was in the mood, anyway.

"And how can I please you, sir?" It had taken her a while to get the voice right: just enough of a non-inflection. Mama School. The Medicos. And something that was just part of the Act.

The programs were varied, and rumors circulated. The Units, the Autos were soft and hardwired to be the best, they could surprise you, so Fields was loose in her Act. Without waiting for his commands, she got up and walked to him, listening to her cables sing across the futon. A tinge of fear again: maybe he suspected, maybe the dye was wearing thin, maybe he knew the real thing. But he didn't move, just let her come forward, drop to her knees and breathe on the tent of his pants. "Will you allow me to pleasure you?"

He shook his head and moved past her to sit on the stool. "Come here—" patting the fine synthetic of his suit leg.

The tone was just right and the Act reached beyond even Fields to click her into it. Like a dancer who knows

the right moves to get from one end of the stage to the other, Fields moved her head just so to untangle the trailing decorative umbilicus, a debutante's hair toss, a flirt's bat of shaved eyebrows, and a step, walking an invisible line to get her hips and bare breasts enough of a sway. Her lip got jutted: impertinent and pouty, her hands ran through her non-existent hair and, instead, tugged a bit on the cables to make sure they didn't grab or snag. Across the room now, in front of the Client now, she stuck a finger under her chin, lowered her eyes and shuffled her feet.

She made a move to make a noise ("Daddy?") but caught it in her throat at the lights in his eyes, the firm tent in his finer pants. The Act had her then, and it had him. His fire and need leaped the gap as she moved closer, putting him into her heat—letting it wash over him.

"Come here," he said, patting his knee.

She nodded, her age now lost somewhere between naughty girl and playing strumpet, and moved towards him, letting the tingling of his excitement bathe her. Her eyes batted, part Act, part his excitement.

On this Now Daddy's knee, she turned and looked at him. So close, so close, the heat of him, this was his treat, this was what he'd come for. She didn't pretend to know (his hand lifted and traced a fingernail line up the side of her arm and across her left shoulder) what drew them to this with an Auto, but they came. Maybe this was something tight and shut and secret within him, maybe he had suggested the game to someone else and they'd shut it down further so now the only person he could tell this heat to was someone artificial and consciousless. Supposedly.

On Daddy's knee, she arced her back just a bit. One thing they always did come for was the fresh enthusiasm. It was perfect for Fields, she really looked forward to each and every chance to refine the Act. An Auto would treat each and every client as if they were the only Client, man, woman, in the world. They matched: the fact of what she

was supposed to be, and what she was.

His breath was hot and faster, it warmed the side of her left breast. The nails turned and glided under: her nipple tightened and knotted in front of his eyes. His breath tingled her nipple and she ached to reach around his head and draw his hot and soft (she knew, she knew) mouth to her nipple, to reverse the play and become mother to him. But she resisted, and let she him take the way.

The hand dropped to her thigh and rested there. She resisted again, trapped in the Act. Fields was in bondage to her performance: Think like the machine, be the machine and let the Act take its way.

I like being the machine, she thought, her mantra as he pushed a bit against her tight thighs, so she took the cue and spread them just so. I must be the machine.

The terror came as he brushed his fingertips up along her slit, tickling the bead of her clit. The Act: she responded a bit late, a second after the thrill itself, the wave itself, went from pussy to head. A second delay. A second second, and she moaned slightly. She wanted to turn and slip off his leg, turn and face him, spread her legs to let his fine, smooth fingers (nails trimmed professionally short) to touch her, to explore her. She wanted to be free, but the Act was around her, close and confining. Invisible bondage of acting.

He said something. Something lost in the heat.

"Pardon, sir?"

"Have you been keeping clean?" he said. His voice was constrained and hard, but broke with a crack of excitement. These were his lines, and the fact of it actually happening was taking its toll on him.

"Yes, Daddy" she said, tones of slight shame, embarrassment. Resting her hands on her own thighs, she spread her own legs a little wider on the balancing Act of his knee.

"All over?"

"Yes, Daddy"

"Even your coochie?"

"Yes, Daddy." (*Machines do not laugh, machines do not laugh, machines do not laugh... you sweet, crazy guy.*)

She knew the next: "How did I tell you to do it?" but that didn't stop the tingle when he really did say it. Leaning back into his arm, tucking herself under his arm, she put her head on his shoulder: a silent language *I'm embarrassed.*

He stiffened somewhere else, and she could tell that a wave of shock had made its way through him. This was almost, his thoughts almost ringing through her head, too real. The fear made him soften a bit under her leg, made his posture twist. Too real, too real.

Time to bring him back, to let him go. Give him his money's worth: she whispered her adolescent fear into his shoulder again *I'm embarrassed, Daddy* and let him stroke her back, tsk-tsking her into comfort.

"I use a washcloth on my private place," with small hands over her slightly-spread thighs.

It took him a while, coughing it up from his own real embarrassment through his brain via his now-hard steel/rock cock. "...careful to clean everywhere?"

"Yes, Daddy."

"Especially your pearl."

Quiet, shushed. "Yes, Daddy."

Knew the next line, too, but let it come from him real and quite strong: "Show me how you do it—how I told you to do it."

Dropping her hands into her lap, she spread a bit wider, balancing herself on his knee, leveraging herself on the ridge of his cock. Her clit was a tiny button under her finger, and the first touch was almost too much, too hard and chafing. The finger went down lower, scooping up a shine of her own juice, and returned to her knot. The first stroke was clumsy and childish, in character: a quick, hard rub up and down with the meat of her hand, pressing up and in. The feeling tore, rather than washed over her. It was a near-kick in the clit. It was too much too hard too soon and

she had to use her Act, use the breathing of the machine to keep from making a noise. State of the Art, she thought, gripping herself inside to keep from making noise, tightening her thighs too much. State of the Art—

"That's it, that's it—" his voice a deep whisper in her ear "—it feels good to clean yourself, doesn't it?"

That was the way she would have started, if she was what he really wanted, so she had given it to him. But that was the Act, that was the realism that he wanted from a machine. Now what he really wanted, what she really fucking wanted: the next stroke was leisurely and circular. She cupped hand in another hand and moved them slow counter-clockwise, cupping and working her cunt with her fingers. One thumb stroked and ringed her hardening and hardening clit while the other fingers and the other thumb worked into her cunt itself, relishing the muscularity of her, the rings of her muscles, the little no-man's land between cunt and asshole.

Under her, behind her, Fields felt him tighten, and caught a whiff of the metal tang of his excitement. The gates had been passed, and the Act was running smooth. A quick jill come climbed up out of her cunt in a series of throbbing quakes, Her legs, her thighs, her tummy jiggled with the coming wave, and she pressed harder and moved faster, and chanced a quick skirt right across the top of her clit.

The orgasm was real—it reached out of her cunt, through her gut, up her throat in a low moan, finally spilling out of her lips.

Leaning back, she twitched and quaked in his arms. She let herself fall only so far, not letting him have to support her entire weight. She was, after all, supposed to weigh something like five hundred pounds.

Propped, balanced on his leg, she let herself slide down to a crouch on the floor. His hand was on her shoulder, stroking her. His fingernails were lights gliding through

her closed eyes. A good performance, a fine come. Act 2:

Turning, she pulled herself now back up, pulling with all her real weight on his pants, climbing the fine suit with clenching hands till she was where she needed to be.

Rubbing the bar in his pants, tracing with her first and little fingers the crown of his circumcised head, she admired it, lost herself in her contemplation of it, getting off on its length (average) and hardness (the Act was really working, it really was). She was contemplating, working herself up with another hand between her legs (and the sweet slick noise of her cunt juice, and her hard clit swimming in it), and she was feasting on his cock without really touching it.

Sign: his hand gently rested on the back of her head. "Clean Daddy now."

With fluttering skill, she found the zipper and glided it down on its nylon-Teflon teeth. His underwear was peach and also silk. A dark, salty-smelling dot ended at the tent of his ridged crown.

The material was clean, with the fine wine of his sweat and the tingle of a few pubic hairs poking through the fine material. She washed it with her tongue, bathing him, tasting the salt of his pre-come. Fields pulled back and admired her work: a darker spread on the fine peach: his cock becoming visible through the damp fabric.

His pants came down: fingers snaking up, she hooked his belt with one hand, unbuckling with the other. With a hiss of Tokyo tailoring mastery, and the creak from the stool as he stood, they came down.

Dimly, as she pulled down the peach and licked and kissed his hard cock, she was aware of him undressing over her. Tongue around the head, tasting salt, and salt, and skin and skin. Hands in his short, almost shaved pubic hair, fondling his balls, feeling the wrinkled sacs, the bristling hairs.

Too quick maybe, too sudden probably, but he was hanging way down, his breathing was quick and deep, his

legs were columns of meat and tension. He slid down her throat: the head rubbed against the ridges of the top of her mouth, hit the softness, smoothness, warmth of the back of her throat. She swallowed and pulled him close, and kept swallowing him down and down, using those hungry, swallowing, eating muscles to draw on his cock, milk it, and work it inside her.

Dimly, through all this, she became aware that her other hand was back inside her, three fingers deep and working her own reverse throat, playing with the twitching, clenching muscles of her cunt. Her clit was a tight singing, throbbing, pulse between her legs. She soothed it and calmed it and bathed it with a circling thumb, pressing on that special spot just to the right of her slit, hitting her special COME button at just the right instant—

—and somewhere, he was standing over her, his hard, hard, too-hard cock down the back of her throat and she was consuming him, swallowing it down deep—

—and somewhere was the room, somewhere was Fields and her trailing umbilicord prop in a small room in an old factory building in the old, bad part of Kyushu—

—and here was Fields in the Act, connected and linked to this man, this man who came to her, who let it down and showed it to her, and she played with it, and make it real safe and fucking hot. State of the fucking Art—

—and he came, a shudder and two hands hard on the back of her head, not pushing, not forcing, just holding himself there. The jets (one, two, three, four—good boy—five, six...) were beyond taste but his body relaxed and oozed the come out of his skin. He broke out in a head-to-toe shine of sweat and giddy release.

Opening wider (was it possible?) she eased him out and kissed and licked him clean, then let her own deep and rumbling come, a thigh-trembling and spine arching (was that her head on the floor, was that his hand on her hand, steadying her, easing her rough ride?) spasm that left her panting almost out of Act, almost to the edge of mumbling "Fucking grand, man—"

Final Act, lady and gentleman: She got to her legs in a supreme Act of control (without a quake, without a mumble, no hand to reach to steady herself) and walked to her private corner of the room.

With the stainless steel bowl of warm water and the soft cloth, she bathed and cleaned his cock and balls. She let him prattle a bit, his "Oh, Gods!" and such washing over her. Applause. Applause. Applause!

Cleaning done, she helped him dress: cocksucking whore to Geisha in one quick move. The Act for him was over, the orgasms tasty and filling. The Act, though was not quite.

Fields showed him to the door, and concluded with a "Thank you, sir. Please come again," in the voice, in the Act. The tones of coolness, not of boredom, but of very, very expensive circuits. Stance slightly stiff, slightly posed, more than slightly mechanical.

She closed the door behind him and stretched out on the futon. The applause of her come, the applause of his come, the applause for the Act. This was someone, and something, she really, really, enjoyed, and could do a really, really long time—

The purr interrupted her quick sleep—just long enough for her head to rest.

Mama glowed, a wrinkled goddess with a thin black cigarette, as always, between broken tombstone teeth. In chopped English she woke Fields up—

—the message worked its was through ("Okay, Mama—okay..."), "He say he want you—"

"That's great, Mama. I'm broken, though, right? Little Miss Robot busted for the night—"

"No, no, no, he want you. Buy you. He want buy you—"

Fields smiled back at the broken, smiling, teeth. "Good night, Mama."

Applause, applause, applause...

...to sleep.

The Portable Girlfriend
Doug Tierney

"Hey, wirehead, wake up." Jack Bolander felt the vibrations through the floor as his roommate pounded on the bedroom door. The sunrise coming through his window turned the yellow painted-over wallpaper a sick orange color, the color inside his head when he wired in without any software in the 'Face. Ron pounded the door harder. "You're going to be late for work again, asshole. If you get fired, I'm kicking you out in the street."

"Yeah, yeah, I'm up." Bo had been lying awake for a while on his bare mattress, staring at the water-damaged ceiling, drawing pictures with the rusty brown splotches, and trying to forget his dreams. Unconsciously, he stroked the inside of his left thigh, but he stopped when Ron kicked the door again. "I'll be out in a minute."

"I'm leaving in two minutes, with or without you."

"I said I'm coming." He dressed without looking down at his body, without glancing down at the lacework of shrapnel scars that ran from his right leg, across his crotch, to his left hip. He stuffed the 'Face and wires into his rucksack along with a couple disks before he pulled on his boots and his field jacket. He didn't bother to tie the boots; he'd do that in the car. Stepping out of his room felt like stepping into someone else's house. Ron had furniture and house plants and cats. Bo had a mattress on the floor, piles of clothes, and milk crates of software. Sometimes he slept in the closet when he couldn't stop dreaming about the war.

In the car, Bo pulled out the 'Face and wired the first disk he pulled from his bag without looking at the title.

Do you want me? The woman, a brunette with huge conical breasts that defied gravity, appeared where the dashboard had been a moment before. She gave Bo a heavy-lidded look of lust with her wide brown eyes. Through her left nipple, Bo saw the hubcap of a passing truck. He popped out the disk and saw that it was a piece of AIC barterware he'd picked up in trade a few days before. Cheap, low format, look-but-no-touch kind of thing, even slightly transparent. Masturbation material, if you kept the lights down low.

For the second disk, he made sure he picked his only MASIC tri-disk. Full-sensory including tactile, capable of carrying on a conversation, it remembered you from one session to the next. The sim—called "Carson", for Kit, not Johnny—lived on a thick black-and-green MASIC wafer chip sandwiched between magneto-optical disks. The startup reminded him of the prairie, the sound of wind in the grass and the smell of rich black coffee and dirt. Across the bottom of his vision, the 'Face captioned in bright red script:

Warning: License period expired. Three (3) days remaining in renewal window. Proceed at your own risk? [n] He chose to go ahead. Bo had gotten the Kit Carson sim free with the 'Face, but like everything, it's only free until you're hooked. The renewal would cost most of his savings, and he'd planned something else for the money.

Hey, pardner. You got an upgrade code for me? Kit shimmered into existence in the back seat of the Saab, dressed in red plaid and dusty chaps. He smelled of gunpowder and horse, chewing tobacco and leather. Kit slapped Bo on the shoulder, a warm, friendly gesture they'd both grown accustomed to.

"No, I guess not. I just thought you might want to bullshit for a while," Bo offered. Ron sat in the driver seat, oblivious to the silent conversation taking place beside

him. Bo turned to see Kit better, and the sim shuddered when Bo jerked the power cord between the 'Face and the battery pack. "Heading to work, and the yup's not speaking again."

Well, ol' pal, I'd like to stay and talk. Kit flickered, and suddenly he wore a business suit and tie. *But as you know, it's against the law to access unlicensed MASIC media.* He blinked back into his chaps and cowboy hat. *So until you get off your cheap ass and pay the renewal fee, I've got nothing to say to you, low-down, software-rustling loser.* He flicked Bo's ear with his finger, an electric shock that ran down his neck to the shoulder. *Cheapskate son of a bitch, pay for your software.* Kit's fist almost connected with Bo's jaw before he popped the sim out without powering down. The cowboy dissolved with a squeal, and Bo tossed the disk out the window.

"What was that?" Ron snapped, looking back.

"Bad disk," Bo said and rolled the window back up. He considered throwing the AIC vixen after the MASIC hombre. Then he thought about how short he was on licensed softsoft, and decided against it. He knew where he could get a black box to defeat license protection, but if he had that kind of money, he'd go ahead and buy the house and the Ferrari instead.

Ron dropped him off at the gate of the auto plant, where he worked for just above the minimum outrage, running a robot welder. His workstation sat like a slick green throne in the middle of a scrubbed concrete assembly line floor. The whole building echoed with its own between-shifts silence while Bo inserted the manipulator probe like an IV into the socket in his right arm and keyed the machine to life with the magnetic tattoo on his thumb. The work was on the level of autonomic, barely a conscious effort in the whole process, just a well-practiced dance of fingers flexing, pointing, gripping, rolling, until all the parts were fixed together. Unable to read or wire up while working, he'd once tried masturbating and had arc-welded the trunk lids shut on three sedans by mistake. He

could only sit and doze and wait out the shift, gripping a soft rubber ball in the working hand.

Everyone got paid at the end of the shift, and Bo wired up to check his bank balance. With the automatic deposit, minus his rent, he finally had enough. He'd saved up his money for months, socking away spare change, skipping meals whenever cigarettes alone would get him through. It was time for Jack Bolander to go downtown to find himself a date. Not just any woman, though. He had someone special in mind.

The last several weeks, she was all he'd lived for. He rode the bus into the growing Boston gloom, knowing he'd have her soon. The excitement of it was an electric pulse down the inside of his thigh all the way to the knee. When he noticed he was tapping his foot, he tried to stop, tried to be cool, but it didn't last.

The dark seemed to flow up around the windows of the sick yellow and stained white bus as the driver pushed his way through traffic to the core of the city. Darkness seeped up from the sewers, slicking the sides of the glass and concrete towers, turning the streets into a sodium-lamplit tunnel. The bus hit a pothole so hard the windows jarred, and Bo nearly fell off his seat.

"Fuckin' streets," the driver muttered. "As much money as this city makes offa parking tickets, you'd think they could repave this place once in a while." He hit another crater, so hard it could only have been intentional. "Like fuckin' Beirut."

"It's more like Goradze." A suit next to Bo spoke, a comment meant to open a conversation.

"Before or after the Ukes carpet bombed it?" he asked. The other man either missed or ignored his sarcasm. Bo checked the guy over and didn't know which to hate more: the euro-styled hair or the entrepreneurial smile. Bo decided on the smile.

"During," the man said. He pulled back his mop of blond hair and revealed a teardrop-shaped scar running

from the corner of his left eye back up over his ear. He'd had an ocular enhancement removed. Another wired up vet. "Forward observer."

"Three-thirty-second Mobile Artillery," Bo replied. He peeled back his sleeve, a ritual showing of scars. "Gunner. Still wired. You probably called in fire for us."

"Many times. That was the shit, wasn't it?" He shook his head. The bus's brakes squealed a drunken scream Bo felt in the base of his spine. The man pulled out a business card and passed it to him. "I'm Scott Dostoli. Listen, I'm starting up a consulting firm with a couple other wired vets. The pay isn't great, but it's better than that workfare bullshit the VA keeps pushing."

"It beats jacking off a robot all day."

"Without a doubt," he said and stood up. "I get off here. Give me a call, okay?"

"You got it." Bo smiled and threw him a lazy salute. When the suit stepped off the bus, Bo threw the card on the floor and went back to watching out the windows. "Fuckin' Spyglass Johnnies," he muttered. Several minutes later, the bus turned onto Essex Street.

"This is my stop," Bo said. When the bus didn't slow down, he yelled, "Hey, asshole, this is my stop." He stood up, catching himself on the worn aluminum pole as the bus swerved to the curb. The brakes sounded even worse up front, grinding metal on metal. Bo shouldered his green canvas rucksack and brushed his greasy brown hair from his face.

"Ring the fuckin' bell next time." The driver cranked the door open and yelled, "Essex Street! Change here for the Orange line."

Essex stank of rotting fish and urine in the gutters. Bo had forgotten how bad it could be in July. The summer heat blew up the alleys from the South End to mingle with the thick brown smell of the Chinatown dumpsters, the bready reek of stale beer, and the Combat Zone's scent of lust and cigarette ash. Bolander breathed in short, tight

breaths through his mouth as he shuffled down the street, trying to look as if he were going somewhere else, shoulders hunched, weaving between refuse, trying without success not to make eye contact with the dealers and junkies haunting the corners.

"Hey, my man, you look like you're after a date." The pimp stood a head shorter than Bolander, but his arms were thicker, his chest broader. Muscle didn't mean much on the streets anymore, not when any punk or junkie could afford a gat or a taser, but it never hurt to look the part of the tough. He wore a tight black Bruins T-shirt and a black Raiders cap, and he smelled like cheap musk cologne. "Got a nice Asian girl, big ol' tits, just waiting for you. Guarantee you'll like her."

"Not interested." He tried to push past the pimp or to outpace him, but the man stayed with him, shouldering him toward the plate glass door of a cheap hotel with red and gold Chinese screens in the lobby. The sign over the desk advertised hourly rates.

"You like a white girl, izat it? Stick to yo' own kind?" He angled so he was chest-to-chest with Bo, backing him toward the doors once again. As Bolander spun right, away from the hotel, away from the pimp, the greasy yellow light of the streetlamp glinted orange off the metal stud on the back of his head, between his brown hair and the gray collar of his fatigue shirt. The pimp saw the wire port, and Bo saw the pimp seeing him. "Oh, so that's how you play. Hey, I can set you up with some softsoft, good shit, straight from Japan."

"Not interested. Back off." Something in Bo's voice, a hot edge, like bile in the back of the throat, made the pimp take several steps back, hands raised, the pale palms ghostly and disembodied in the shadows and uncertain light.

"Hey, wirehead. You just gotta say so." He stepped back a few more paces before turning his back to Bolander. "You a wire freak," he muttered, still loud enough to hear. "Don't fuck wit' no wire freaks."

Bo pulled his collar up over his port and covered the rest of the distance to the shop in strides lengthened by both adrenaline and anticipation. He glanced around once to make sure no one was watching before he ducked through the door of Abbe's Cellar.

As far as it went, the Cellar was about the norm for the Zone, the usual stacks of porno movies and erotic magazines in their stiff shrink-wrap, glass display cases of adult toys of every improbable shape and size, a lot of B&D leather and masks, as the store's name implied. Unlike the other places on the street, though, it was a little darker, quieter. It had more atmosphere, and their prices kept the lowlifes out. Instead of being a poorly lit supermarket for human lusts, they catered to the desires, the fantasies. Their clientele were businessmen on their way home to someone, picking up a gadget or a piece of silk that would repaint the faded colors of a lover's smile and restore the sharp-edged, naughty gleam in a wife's eyes, the look that used to say, "my parents are going to be out all night... I'm so glad you stopped by." Abbe's also took pride in being on the cutting edge. Softsoft, ROMdolls, network services.

Bo didn't bother to sift through the collections of paraphernalia in the front. He didn't even consider the bulletin board where swingers posted their parties. What he wanted—who he wanted—was in the back room, waiting, sleeping, ready to wake up to his gently insistent kiss on the back of her neck. Maybe she'd been waiting as long for him as he had been for her. The further back he went, the less the Cellar looked like a shop. It came to resemble a basement or a lonesome middle class attic full of boxed history and old thoughts, faded and threadbare as the clothes that hang in the back of a closet. The leather harnesses and silk bonds didn't glare with the orange and blue scanner-coded tags like they did up front. Some didn't even have tags at all, hanging like personal mementos in the owner's den.

It was hotter in the back, where the air conditioner

didn't quite reach. Bo shifted his pack from one shoulder to the other as he shrugged out of his mottled gray and black field jacket. He knotted the sleeves around his waist, feeling self-conscious of the hardware and of his small tank-gunner's frame. He felt bigger with the jacket on.

"Help you find something?" Abbe came out of the store room, a can of diet something in his hand. He was a bit shorter than Bo, about five and a half feet, close to two hundred pounds, give or take, balding on top but he made up for it with facial hair. He wore a white silk bowling shirt with red trim and sweat stains under the arms. His name was embroidered in red over the pocket, and some-how, he smelled clean. Not clean like showered, or clean like the Boston air after a summer thunderstorm when the sun finally comes out. It was clean like skinny-dipping in an icy spring-fed pond in the hills. His smell made Bo com-fortable and took the nervous edge off their conversation.

"I've got something particular in mind."

"Okay, that's a good place to start." Abbe dragged a wobbly barstool from behind the curtain and offered it to Bo. When he declined, Abbe grabbed a magazine from the shelf and tossed it to the floor to prop up the short leg. "What exactly is it you'd like, and we'll see if we can hook you up." He struggled up onto the chair, still not quite on eye level with Bo.

"I'm looking for a girl." Bo was surprised to realize that he was embarrassed. He'd been chewing his lip, and his voice caught like dust in his throat. "I'm looking for a par-ticular girl."

"You look like a smart kid," Abbe said. "You go to Tech?"

"No," Bo said, looking around at the low glass cases that lined the walls. Somewhere, in there, she was waiting for him. "I'm not in school anymore." He wondered if he should really be so nervous. His knees felt warm and weak. "She's on MASIC format."

"Tri-disk. I figured you for the high-end type. That's

Mil-Spec hardware, isn't it. Not that cheap Japanese enter-
tainment-only shit. Hold on, Colonel." Abbe leaned back
through the door to the back room and called to someone
named Janet. Bo couldn't hear her reply, but her voice was
like speaker feedback. "Just get out here and help this boy.
When I want your opinion, I'll start paying you for it."

"You watch your mouth, you old bastard." Janet
stepped through the curtain, and the first thing Bo saw
was her eyes, huge and brown and slightly bulging. With
her combed-up puff of mousy brown hair and her slightly
puckered mouth, she had the inquisitive look of a large rat.
Her tight blue and tan shirt showed off her small, slightly
sagging breasts. "What can we do you for, son?"

Bo hated it when anyone called him son. Even his own
mother had just called him "kid." She waited, and her at-
tention made him sweat, as if she were waiting for him to
name some wild and illegal form of perversion, or perhaps
waiting for him to run away.

"She's got long, wavy black hair and blue eyes. Slender.
She looks Black Irish, if you know what I mean." Bolander
looked around, as if invoking the description might cause
the package containing her to stand up of its own volition,
call to him, plead to be taken home. "I saw her here once
before, but I don't remember her name."

"I know what you're talking about. There's only three
on tri-disk, and the other two are blondes." Janet slipped
into the back room before Bo knew she was leaving. There
was nothing mousy about the way she moved. She was
quick and lithe, and when she returned, she seemed to
glide to a stop in front of him, the package in her hand
waving under his nose like the bough of a tree in a breeze.
"This her?"

Bo tried to speak, but only managed to mouth the word,
"Yes."

"Cash, or can we debit it discreetly from your personal
account?" Abbe finally asked. Bo handed over the tightly
rolled wad of large bills he'd picked up at the bank. Abbe

unrolled the money and handed it to Janet. "Cash customer. The mark of a real gentleman. Always deals in bills."

"There's only eight thousand here," Janet said after counting the stack twice. "Perpetual license is fifteen."

The words made Bo go cold, the way looking into the rearview mirror and seeing police lights turns the flesh to gel. He couldn't wait long enough to save up another seven. Not after coming here and seeing her up close. If he left without her, he'd lose his nerve, probably spend most of the cash on booze, trying to forget about the whole thing.

"What can I get for that?" he asked, his voice dry and cracked. She thought about it several seconds.

"One year unlimited usage license, renewable or upgradable at added cost."

"Whatever. I'll take it." Bo didn't even have to consider the options. He could come up with the other seven in a year's time, maybe. What mattered was having her, now. Janet filled in the license agreement and coded the init disk while Abbe bagged the purchase. Somehow, Bo had imagined her coming gift wrapped, not tucked into a brown paper bag. Seeing her face there, shadowed by the coarse, unbleached paper, a touch of reality tickled at the back of Bo's mind. After all, she was just a program...

"Good call, kid. You'll like her. She learns how to be the lay of your lifetime. Anything you want, she does it. Here you go." Abbe handed him the bag, and the clean smell of him broke the morbid spiral of Bo's thoughts. He took the bag and left, glancing back once to wave, awkwardly, at Janet and Abbe, deep down, perhaps, wondering what they thought of him.

Outside, in the fading heat, he turned down the block to avoid the gauntlet of pimps and pushers. A bus was just pulling to a stop at the corner, and he dashed to make it, slipping through the doors as the old diesel groaned away from the curb. He ran his pass through the reader and slipped to the back of the bus. He was alone there except

for a small, slightly heavy blonde woman in a business suit and white sneakers, who was reading a self-help guide to AIC interfacing. She didn't even look up when Bo collapsed to the seat across from her.

It was full dark outside, or as dark as Boston ever gets at night, the humidity like a curtain dimming the streetlights. All the lights were out on the bus, but Bo could still see to read. He pulled her package from the bag and started going over every detail, the specs on the back, the advertisers' pitch on either side. He'd seen it all in the magazine ads. Then, on the front, he stared several long, breathless seconds into her eyes.

I'm just going to read the documentation, he swore to himself. Just the docs. He slipped the tip of his pocket knife into a crease in the cellophane wrapper, slit it all the way around the bottom, and slid the top slowly off the box. A breath of flowers, gardenias and lilacs, rich but too sweet, drifted up to him from the perfumed papers inside. Bo would have thought it tacky, had he not been so thoroughly enthralled. Wrapped in another cellophane bag, tucked under the curled and creased paperwork, she was there. Not much to look at, just a shiny gold and green ROM disk and a plastic-coated magnetic RAM, sandwiching a thick black MASIC wafer. The plastic mounting piece was the same color as the ROM. Without a second thought, he broke his oath, reached into his canvas bag, and pulled out his 'Face.

The slim black case was no thicker than a old cassette player, with one slender wire that snaked back to a power cell in Bo's bag and another thicker wire with a gold, brush-shaped probe attached to the end. Bo pulled aside his hair and flipped open the cover of his jack with the same quick, casual ease as someone pops out a contact lens. An electric tingle ran across the base of his scalp as he slid the probe in and secured it with a half-twist.

Being wired was like being inside the TV looking out, like being the electron, fired toward the phosphor screen

and becoming part of the image. Being wired was visual, aural, olfactory, tactile. So wonderfully tactile. Even the startup routine was a caress that ran the length of his body, the light, tender touch of a friend that would have tickled if it hadn't felt so good. It was the breath of a lover on bare skin, a mother touching the cheek of her sleeping child. All by itself, it was worth the risks of wiring, worth the loneliness of nights lost on the net, the madness, the days when the headaches made his vision turn red.

Bo ran his imprinted thumb over a hidden sensor, and a panel slid away with a barely audible sigh. He fit the media into the slot, and the gold plastic mounting clip came away in his hand. He fed the thumbnail-sized init disk into another slot and waited. Words in red floated in his lower peripheral vision, seen as if through the lens of tears.

Configuring to Aminoff-4 interface...stand by...

Then she was beside him, quiet and prim, reading a book of poetry. His eyes wandered over her, soaking in the details of her smooth, pale wrists, the thick tweed of her skirt, the blue-black sheen of her hair. She glanced at him out of the corner of her eye, and she smiled.

Hello? Her voice was much lower than he'd imagined, and soft as a down comforter in winter. There was more, though, a depth of understanding and a predisposition to laughter.

"What are you reading?" He became self-conscious about trying to look over her shoulder and scooted away, putting most of a seat between them. His eyes fixed on a blemish in the blue plastic of the bench where he'd just been sitting.

It's Rimbaud.

"Oh." One of the hot bands on the club set was making fistfuls of loot reading Rimbaud's poetry while playing ragged jazz and electric guitar solos. Bo thought they sounded like posers, so he never listened. But he still recognized the name.

I'm Sarah-Belle. I prefer just Sarah. Her voice drew his

eyes up from the seat to her own, and something passed between them, some exchange of trust that Bo knew, deep down, was simply excellent programming. It caught him off guard, and he opened up to her without another thought. He smiled, for the first time in longer than he could remember.

"My name's Jack, but I go by Bo."

Voulez-vous etre mon beau? His 'Face subtitled it for him, in yellow, just below her lips.

"Don't speak French," he said anyway. "I don't like the way it sounds." There was the barest pause, a slight flicker around the edges of her cheeks, a minor realignment of her straight, dark brow. Bo glanced down, and her book was Donne instead.

"Make love to me." He said it almost before he knew he was going to. The look on her face was a intermingling of amusement, interest, indignation and irritation. He felt somehow he'd broken the rules, and even after he consciously realized the rules were his to make, he still felt uncomfortable under the study of her clear blue-gray eyes.

Here? I don't think that's a good idea.

"Yes, here." He'd said it, and though he wanted to back down, he couldn't. He wouldn't be chastised by a circuit board, even if it was a Turing chip and probably smarter than he was.

Here? she asked again, teasing him with the unspoken promise in her voice. She ran one finger down the side of his neck, and with the other hand, she began untying the sleeves of his fatigue shirt. *Right here? Are you sure? I've never done anything like this before.*

In the lower left of his vision, a single pale icon appeared, pulsing every several seconds, DaVinci's Balanced Man, an indication from his 'Face that he'd entered a much deeper level of input, direct to the tactile centers of his brain. Everything that happened, while it was lit, would be confined to the spaces of his mind, every spoken word, every touch, every kiss. Like a dream, but a dream that

paralyzed his voluntary nervous system. His awareness of the world faded to peripheral. Only a few telltale twitches betrayed the activity taking place in the small black box and in his mind.

Bo started to speak, but Sarah silenced him with a kiss, and her lips were soft, forgiving. She had the kiss of someone who smiled often, a kiss that gave way under his, that parted for him and drew him in deep, the softest, most passionate kiss he'd ever had. It relaxed him and drove him to the edge of panic all at once. His pulse pounded in his neck, in his temples, but he felt secure, warm, and content. The kiss said she loved him.

Without breaking the kiss, she slipped onto his lap, wrapped her arms around his neck, ran her fingers though his hair, across his cheek, down his chest. She touched his right thigh, tingling where in reality he had only numb scar tissue. Slowly her fingers walked up the front of his jeans to the zipper, touching lightly, teasing, exploring, finding. She pressed her hand against him, squeezed him through the ragged denim. Bo felt release at last, and he let out a small, whimpering moan.

Sarah broke the kiss, pulled back enough she could see his eyes. Her smile was sly, but her eyes were delighted. With her fingertips, she stroked him firmly, and he tried to smile before embarrassment got the better of him.

We're going to have to do something about this, she said, and burst into laughter as he sheepishly rolled his eyes. Her laugh was as light as sunshine after a cloudburst, but at the same time just a bit silly, and still heartfelt. It reassured him, told him she was not laughing at him but because he made her happy. Bo melted into her laughter, closed his eyes and savored the sound as much as the sweet taste of her mouth that lingered on his lips.

She unzipped his jeans with both hands, took care that nothing caught or snagged. She spread her skirt over his lap and settled onto him, unbuttoned her white blouse, revealed small, round breasts, pale as clouds, and peach

nipples. Sarah paused when she saw the expectant, frightened, slightly horrified look on Bo's face. Sarah winked and smiled a slow easy smile.

Hey there.

"Hey." He smiled back and knew he was ready. She threw her head back and slid onto him with a pleased moan. A tingle ran down the length of Bo's body, arched his back, tightened every muscle. Microcurrents ran the length of his body, analog touch poured directly into his brain. Her scent drifted up to him, floral and spicy, enticing. She was there, and she was wonderful. Sarah rocked back and forth, smiling, eyes closed. Bo found the pleasure she took from him more erotic, more stimulating, than the feel of her. She made love to his ego, and it drove him over the edge. She collapsed onto him, her head on his shoulder, and kissed his neck. Sarah kept him afterward, squeezing him with quick, tight squeezes that sent a new wave of endorphins flushing through his body.

Finally, she sat back, let Bo look at her, let his eyes and his mind drink in the woman who had just made love to him. Her hair cascaded around her shoulders like dark silk. For the first time Bo touched her face, found it warm and smooth, her hair soft as cashmere. Sarah turned to kiss his palm before she spoke.

Isn't your stop soon?

"I think we passed it."

Oh. Sarah gave him a quick kiss on the lips and winked out suddenly, reappearing beside him prim and immaculate once again. The thin volume of Donne lay beneath her folded hands, and she looked exactly as she had before except for the sated smile and casually flirtatious wink she gave him. The DaVinci icon faded, and Bo was free to move once more.

He started to get up and felt the slick, sticky wetness soaking through his jeans. He pulled his rucksack across his lap, blushing a deep scarlet. He hit the bell and yelled for the rear door.

"You said it was a bad idea, didn't you."

It's okay. Sarah caressed his shoulder through the thin cotton of his T-shirt. She broke into a broad, enthusiastic grin and rolled her eyes. *Okay? It was great!* They both laughed as the bus squealed to a stop several blocks west of Bo's apartment.

As he bounded down the steps and into the damp, oppressive Boston night, Bo heard the blond woman mutter, "Wire-head freak." Her epithet drove home the reality to him, that Sarah was just a program, that he was a loser stuck in a fantasy. Then Sarah took his hand, and they walked home together, strolling and chatting like long-time lovers. By the time they reached his place, he'd made the unconscious decision that whatever they had together beat the hell out of his reality apart.

"Gotta turn you off," Bo said when they reached the door. "Ron goes batshit if I wire in the house, and we've been fighting all day." Before she could speak, he thumbed the power stud and unjacked, then stuffed the 'Face back in his rucksack.

The apartment was nearly empty when he opened the door. A couple pillows on the floor and milk crates used as a table. All of Ron's AV gear was gone, as was his computer and the beatup brown sofa where Bo sometimes fell asleep. Bare hardwood floors littered with empty fast-food drink cups and microwave burrito wrappers greeted Bo and informed him that something was very wrong. He checked the door again to make sure it had been locked. It was.

"Hey, Ron?" Bo checked his room, found it as he'd left it, then checked Ron's. The futon was still there, but the tangle of silk sheets was gone. The house plants and bookshelves no longer filled the corners. Bo's footsteps echoed off the bare plaster walls. "That bastard."

Bo found a note on the refrigerator. "Bo, gotta jam. Moved in with Elisa. Later." He'd emptied the fridge, too. Bo went to his room and curled up in the pile of blankets

on his bed. He didn't feel like changing clothes or showering, just sleeping it off and worrying in the morning. Worry refused to wait, and after staring at the water marks on his ceiling for almost an hour, he reached for his ruck, for the comfort of her company.

Hey, tiger.

Sarah wore a white silk camisole that reached mid-thigh and fell loosely across her breasts. When she dropped to her hands and knees to kiss him, it dropped away from her, and Bo saw all the way down the pale, tight curve of her belly. Her body stirred something inside him, but instead, he said, "Can we just talk?"

What's up? She flickered at the edges again before settling down beside him in a half-lotus. She wore an I-Love-NY nightshirt which she pulled down over her knees.

"Ron moved out. No notice or anything." Bo pulled a pillow into his lap and hugged it tight. "He was a real shit, but at least he was company. And I needed him to pay the rent."

Well, we can find you another roommate, right?

"I hope so." For a while, Bo just stared off across the room, realizing after a while he was gazing at the stacks of AIC and MASIC discs piled in a milk crate in his closet. He could sell off most of it and pay for another month, if he got ten cents on the dollar for his original investment. He'd have to find a real sucker to pay those prices for unlicensed disks. He considered selling his 'Face and paying for a half-year, in advance, or taking Sarah back and using the cash to get out of the city, move some place cheaper. He regretted throwing the suit's business card away, even though he could probably find the guy again if he tried.

I'll help you find something. In the morning, Come to bed with me, Bo? You need rest.

"Sarah, why are you so good to me?"

She didn't answer for a while, long enough that Bo wondered if he'd hit a glitch in the softsoft. *You make me laugh. I like being with you. I don't exist without you.* She took

his hand in both of hers, her touch warming and reassuring. She made him feel needed.

"I guess you don't." Somehow, her need for him felt like a responsibility, a reason to work it out. He knew he'd been smudging the line all evening, and finally physical reality was merging with volative reality somewhere in the wire. He knew better than to lose touch, but in the end, it didn't matter to him all that much. "I'm really screwed."

We'll come up with something. I'll help you. You have unlimited usage, remember? I'm not just some AIC-format slut. I think. And I'm clever. She kissed his neck, insistent. *Come to bed?*

Suddenly, physical and emotional exhaustion pulled at his limbs, insistent. "You're right. I need to sleep."

He rolled over and reached for the power stud on the 'Face black box, but Sarah stopped him with a hand on his shoulder. *No. I don't like it when you turn me off,* she said. She curled up tightly beside him, and the DaVinci icon faded into his vision. *Leave the power on. I need to think.*

Like A Reflection In A Mirror With No Glass

Renee M. Charles

From her semi-prone position on the Syntho-Mate-Inc. recliner (head and upper torso resting flat, hips and pelvis raised, legs conveniently spread on separate, swing-out platforms), Tanja could barely see this session's Syntho-Mate surrogate resting on its matching recliner—her gravity-flattened breasts, under the thin drape, obscured her view—but Tanja did notice that this particular model was a Euro-body, with light-complexioned "flesh" and almost ludicrously butter-yellow hair on top, which contrasted sharply with the artfully arranged merkin of black curls below.

The designers must have been hung up on suicide blondes, Tanja decided, as she waited for the Mechi-aide to prep her before this latest Bio-donation, her seventh (or was it the eighth—after a while, especially after the indignity of the first session had worn off, she'd found it hard to keep track) this year alone. Long ago, Tanja had stopped jerking reflexively with fright as the Mechi-aide made its abrupt appearance through the Bio-'nation chamber's swinging metal doors, but no matter how many times she went through the prepping procedure, her heart still yammered in her chest when the wheeled, four-limbed, headless robot whirred over to her head, and deftly applied the brain-link sensors to the thumb-sized shorn spots on her

scalp (after the first session, when the Mechi-aide sheared off most of her hair, Tanja learned to pre-shave those areas, and kept the rest of her hair at a uniform half-inch length, so all she had to endure was the application of the sensors), then whirred down to the spot between her legs, and sheared her outer labia, before applying the remaining sensors to her shorn skin, the already hairless folds of her inner labia, and the pearl-like nub of her clitoris, using that almond-scented, slightly oily, and definitely sticky substance to bond the sensors to her skin, completing the link between herself and the life-like plastiod covering of the latest Syntho-Mate resting on her own splay-legged recliner, before it rolled itself back through the still-moving swinging doors.

Then, another, albeit briefer wait, while the technicians (none of whom Tanja could see, even though they definitely could see her through the banks of two-way, smoke-tone mirrors which lined the walls and ceiling of the small, overheated chamber; as it was, the only live people she ever did see at Syntho-Mate-Inc. were the female attendants who supervised the undressing-briefing area—it was no secret that a woman desperate enough to endure a Bio-donation session might also be desperate enough to rifle the contents of unguarded clothes-belongings lockers—or the gal who gave Tanja her money after the session was over) did whatever it was they did to establish a link between Tanja's living, feeling flesh, and the synthetic, receptive "flesh" of the nearly-programmed Syntho-Mate, prior to activating the Stimu-probes...

I'll bet they take their sweet time just to make sure every one in the room gets a good, long look at the donor, Tanja thought with surprisingly little bitterness; that particular emotion had long since mellowed into a cynical black humor after she'd taken to checking out each finished Syntho-Mate prior to getting off the recliner and hurrying back to the undressing area. Despite surface differences in each 'Mate (black skin, delicate Oriental

hues, artificial tan lines permanently dyed into the "flesh," all in readiness for the company's world-wide clientele), all of them wore an identical, vacuous expression, like a reflection in a mirror with no glass, which belied absolutely nothing of the sexual responses she'd just donated... No wonder they want to get a look at the donor... no matter how pretty they make 'em, no matter how they wiggle their hips and twitch their labia, they're not much of an improvement over those blow-up fuck dolls from my grandfather's day. And the folks who manufactured those things didn't have to pay volunteers for every automated twitch and wiggle...

For a time, Tanja had a so-pay-me-for-nothing attitude; remembering how her own grandmother had to pose for nude pictures to work her way through college, Tanja went through her period of indifference... but always, just before she scurried across the nubby-carpeted chamber floor on her way to get dressed, she'd feel that stab of disappointment when she saw her Syntho-Mate just... lying there, expectant and uninvolved, a waiting vessel for some man's self-involved, self-satisfied physical outpourings. Only, unlike the latex sex dolls with the vibrating vaginas, these 'Mates did have computer brains. With fuzzy logic, if her roommate (and on-off lover) Ingrid could be believed—and, after all, Ingrid was dating (for money, to be honest) one of the technicians who did whatever it was that they did behind those murky mirrored walls... (Although Tanja did find it ironic that the man preferred real flesh-sex, albeit it for hire, but since Ingrid was so much prettier than Tanja, the irony wasn't so hard to swallow...)

Stealing another glance at this latest Syntho-Mate, with her luxurious, glistening waves of aureate hair, and her just-pinched-pink nipples surmounting the artfully asymmetrical mounds of her pearly-pale breasts, and the coiled arabesques of hair framing her puckered labia, Tanja thought, What I wouldn't give to look like that, before

reaching up to slowly peel the tissue-thin paper drape off her torso. Looking above her in the mirror, she appraised her own body, taking in the small but neatly formed breasts with the slightly oval nipples, the just barely convex stomach—now rippled into a creased dewlap by her upraised pelvis—and the semi-bald stubbled labia just barely visible from this angle; not bad, but not... mythic. Not dream-like in its fantasy contours; certainly not direct-flesh saleable, like Ingrid's. Her legs were still draped, but she knew they were serviceably long and lean, a little skimpy in the calf, but then again, the people at Syntho-Mate-Inc. weren't programming the 'Mates to jog... But Tanja's main dissatisfaction was with her face and hair; true, she had good Germanic bones, and her hair—if let to grow—was glossy, but had she been born in her great-grandparents' day, she never would have been considered to be an ideal German woman. Like Ingrid, she found herself thinking, as a part of her still stung at the injustice of her situation... true, in hard times like these, any work is desirable, and after all, Ingrid did warn me that being a Bio-donator takes... how did she put it? "A certain talent for removing yourself from the situation." But do you need to remove yourself from the flesh-sex sessions with your "date" I wonder? True, sessions with him aren't nearly enough to keep either of us sheltered or fed, but... but you never have needed to give a Bio-donation, no matter how much better they pay, have you? You've never lacked for flesh-sex requests, Tanja mentally harangued her room-mate, even as she felt the flicker of wanting for Ingrid stir deep within her own partly hidden sex. And, after all, it was no one's fault that Ingrid was a natural-born blonde...

But then again, this Syntho-Mate's not a real blonde, either. But yet... perhaps something within her could be real, Tanja found herself musing, as the Mechi-Aide finally made its unannounced appearance, first pausing by the Syntho-Mate and gathering up its tendril-like sensor-wires dangling from the prone 'Mate's head and labia in one

robotic arm, then glided over to Tanja's own head (the bare ovals of shining skin there resembled a tribal pattern against the roan covering of her hair) and began to apply the first of the sensors linking her brain—her feeling, but also thinking, needing brain—to that of the waiting 'Mate, first squirting on a daub of adhesive, then securing the sensor... but this time, Tanja mentally advised her latest Syntho-Mate, not even knowing for sure if her words would or could be heard:

Go ahead, enjoy this... you may be more beautiful than I am, but you're not just a tool. You're the receiving end of all this, you're the one he's pleasuring, no matter what he thinks... or you can simply pleasure yourself, if you've a mind to.

And as the aide's moist, sponge-tipped adhesive-spurting arm bore down on the next shaved-clean oval on her scalp, Tanja's mind drifted inward, as she completely, wholly concentrated on that long-ago day when—

—she and her best (and prettiest) friend Marthe were sitting in Tanja's bedroom, trying on the swim suits they'd just bought with their saved-throughout-the-winter allowances, even though the water still wasn't warm enough for swimming anywhere save for in the indoor municipal pool, "—and who wants to go there?" Marthe had pouted (and somehow, pouting seemed to suit Marthe, while it just seemed childish when Tanja did it), as she wiggled into the bottom of her new ruffle-trimmed suit-panty behind the tall, shirred-fabric-covered folding screen which occupied the eastern-most corner of Tanja's room.

There was just enough sunlight coming in through Tanja's western window that she could see Marthe's lithe, slender body silhouetted through the tight gathers of the pink-flowered fabric covering the open framework of the screen; despite the distortion, she could easily make out the nub-like buds of Marthe's breasts, and the slight swell of her bottom, as Marthe stepped out of one suit panty and

bent to pick up the other new suit she'd purchased shortly after their half-day Saturday classes let out.

Both girls were only in the sixth grade, too young yet for shower-afterwards-gymnastic class, but Tanja was already beginning to feel curious about how her friends' bodies looked in comparison to hers—Has their hair started coming in yet down there? Have any of their nipples gotten hard when their blouses rub against them?

From where she sat on her bed, Tanja could see her reflection in the three mirrors, one long, the others shorter, surmounting her vanity table, only each reflection was slightly different, showing her body at incrementally non-identical angles, but she liked the view in the middle mirror the best (it chopped off her bare feet, which she thought too big), especially since she could also see the fabric-distorted reflection of Marthe's shadow in that one... and as her eyes drifted from her own nearly-naked reflection to that of Marthe, her right hand began to drift toward her lap, until she'd unconsciously peeled down her modest suit bottom, until the first reddish curls of hair were visible—

"Oh, you have hair too... I thought I was the only—"

Marthe's voice made Tanja jump in place; when she looked toward her friend, Marthe was wearing her one-piece suit, but she, too was pulling aside the stretchy fabric along one leg, to reveal a dark-brown feathering of hair covering her mons. Her own heart now fluttering in her chest, while her mouth became too dry for her to speak, Tanja just nodded, while Marthe padded over to her and then reached down with a tentative hand to grasp the waistband of Tanja's swim suit, as she asked, "Can I see?" even as she pulled the panties out of the way, until all of Tanja's matted-down vaginal hair was revealed. The sunlight streaming into her room touched the nest of curly hair, turning the reddish locks a fiery golden-orange. With a barely-pressed down finger, Marthe felt Tanja's mound, then wiggled out of her own suit, to reveal her own

rounded corners triangle of pressed-down pubic hair—along with her budding breasts, and concave belly below.

Without needing to ask, Tanja lightly ran her hand over Marthe's mons, before giggling, "If only the hair on our heads was so curly!"

"No more need for permanents," Marthe agreed, before she sat down next to Tanja and said in a low whisper, "My older sister says that when her boyfriend... touches her, down there, she gets all slippery, but even when she doesn't, he uses lotion, which she says feels even better..."

Both girls were headed for Tanja's vanity in a second, looking for a suitable hand lotion, but Marthe found the bottle first, so Tanja hurried to her bed, and laid down, with her legs over either corner, so that her bare mons was supported by the corner of the bed itself. Closing her eyes, and picturing Marthe's boyfriend in her mind (even though she'd never seen him), she found her breath coming in short, hard gasps as Marthe squirted a dollop of the nutty-sweet-smelling creme onto the spot where her wrinkled inner lips met at the top, then—using her first and second fingers in a slow, circular motion—Marthe rubbed the lotion onto Tanja's labia, then used her other hand to gently knead the curls-covered skin over her labia, while Tanja's lower legs hugged the sides of the bed tightly, and her own moisture began to mingle with the lotion, until all Tanja was aware of was the warmth of the sun across her bare middle, the musky-nut-like smell in her nostrils, and the ripples of throbbing pleasure which radiated outward from her now-slippery vagina like rings moving outward from a stone tossed in still water...

The metallic scree of the Mechi-aide's surgical razor-tipped arm moving into position brought Tanja back into the now with a jolt, even as the memory of that schoolgirl masturbation session remained as a warm glow in her mind; glancing above her, she saw the now-humming razor approach her stubble-covered labia, but as the Mechi-aide's arm made contact with her skin (the tingle of the

vibrating cutting edge felt uncharacteristically delicious this time, unlike any of the previous sessions), Tanja instead saw—

—her curls-framed vagina in the reflective circle of the hand mirror her boyfriend had handed to her, as he placed the towel under her pillows-supported bottom, and spread the fabric taut between her spread-open thighs, and despite the fact that Tanja had seen how she looked in private, when she'd examined her genitals in her own bathroom after taking a bath, what she saw now was somehow different, mostly because this was how she looked to Peter, so it was like she was looking at the mons of a stranger, a person outside herself. For a moment, she was reminded of that afternoon with Marthe, and how she'd looked with that drizzle of pale pinkish lotion covering her tight, supple lower lips. That day, the sight of Marthe's openness had been strangely exciting to Tanja... as the sight of her own openness was this evening.

She and Peter had spent several nights together, but tonight was to be different; first he'd shave her, than she'd shear off his fringe of curls around his organs, since they'd read in one of Peter's sex magazines that the experience of bare flesh caressing moist nakedness was incredible...

But now, as she lay on his bed, with her softness exposed and slightly parted, so that her vagina gaped a little at the bottom, hinting at the slippery depths within, and Peter busied himself with his scissors, disposable razors, and can of shaving foam, lining everything up neatly on the dresser-top next to where he was sitting (likewise naked, with his penis already semi-erect) across from her, Tanja felt a rush of pleasure-fear: Suppose he nicked her? Or the scissors caught the hair instead of cutting it? The unexpected vulnerability of her position was a little intimidating; while she'd been spread open during gynecological exams, her doctor hadn't had barbering items at the ready...

"Ready?" he suddenly asked, as he approached her mound of Venus with his hair-cutting shears, and—keeping her mons in view of the mirror she held out at an angle to her body—Tanja just smiled up at him, and nodded. The scissors snicked as Peter alternately grasped (very gently) tufts of her hair, snipped off the curls close to her skin, then set the shorn locks on the towel, before lifting and holding the next tuft, and cutting again. Getting the hair closest to her anus trimmed did pinch a bit, but Tanja smiled anyhow, and watched Peter's seemingly disembodied fingers and the sharp-pointed blades as they freed her now stubbly labia and mons of the reddish curls she'd been so proud of only a decade before, that day with Marthe...

Once she was trimmed, Peter ran his palms against the grain of her hair, until the short bristles stood upright, like an uneven crew-cut on a misshapen, cloven head, and while he shook the can of foam, she reached down with her free hand and felt her close-cropped skin; the sensation of her skin touching the stubble was ticklishly pleasant. Before spreading on the foam, Peter meticulously snipped off a few stray longer hairs, then touched the nozzle of the can against her lower belly, allowing the minty-cool white creme to billow out in a frothy puff that crept into her mirror-view like a wind-scudded cloud. And Tanja felt herself growing moist as Peter smoothed the creme over all her clipped hair; as the head of the plastic razor appeared in her mirror, taking away the foam and the hair beneath in narrow swaths, she found it hard to hold the mirror steady...

Only when she saw the reflection of a smooth, knee-cap bare mons in her mirror did she relax fully; not a drop of blood could be seen, only softly contouring pale skin surrounding the now deep-pink inner labia and gently throbbing, twitching clitoris. The warm air of Peter's bedroom suddenly seemed cooler against her denuded skin, and the overhead light glinted softly off her still-moist curves and

deep folds. Slowly, she tilted the mirror so that she could see the rest of her body along with her freshly shorn mons, as if to reaffirm her disbelief that such a shell-like, beautifully wrinkled and deeply concave bare softness could really belong to her. Reaching down once more with her free hand, she caressed her slippery smoothness, until she felt Peter's head next to her hand, and she moved her fingers to the back of his neck, as his tongue flickered along her hairless labia—and she turned the mirror toward her pelvis, to better see what was happening, until the swell of sensations became too much for her, and her eyes closed of their own accord, and her vision was a red-veined screen before her—

Tanja's eyes snapped open as the swinging doors swished shut behind the departing Mechi-aide; glancing down at herself, she noticed that she'd been trimmed more extensively than usual, until only a tonsure-like thin fringe of curls remained along the upper edge of her mons. More sensors than usual were attached to her down there; Must be a special-order Syntho-Mate, she reasoned, whoever is getting her must've paid extra for the increased sensitivity levels. (Ingrid had once told her roommate about the special-order models; supposedly they had increased memory-capacity, to better serve their owners... if that's the case, Mr. Lucky Owner is really going to get his money's worth, Tanja decided with a smile in the direction of the prone, mute Syntho-Mate across the room.)

And, as a further departure from the normal Bio-donation sessions, the recliner began to vibrate slightly, the only sign she ever had that the automatic probes were about to be released from the enclosed pedestal-like base of the recliner—they're never this fast, her mind protested briefly, before another, more primal part of her brain countered, And you've never been this ready for it...

Not needing to watch the coiled metal probes with the flexible, slightly yielding syntho-flesh ends emerge from

the bottom of the recliner, and—after a fine misting of oily liquid from the one nozzle-tipped probe was sprayed on her bared inner softness—bear down with slight, but firm pressure on her labia, her exposed clitoris, before the main probe slipped into her, Tanja narrowed her eyes as she tilted her head in the direction of the still-oblivious Syntho-Mate, and intensely thought at her:

Put those fuzzy little data banks and ROMs of yours to work... you're only getting one chance at this...

And as the first of the probes made contact with her flesh, applying stylus-like even pressure on the gently rounded folds of her upper labia, Tanja mentally added, Feel what I feel... see what I saw... experience it all—

"You've never done it with another woman, have you?" Ingrid's voice was casual, but Tanja caught the slightly taunting edge to it, as she pulled her head away from Ingrid's pillowing breast, and replied defensively, "I've been with girls... once, a friend of mine and I, we were trying on swim suits, and—"

"But not a woman," Ingrid teased, as she traced the outline of Tanja's right nipple with a pale-pink painted fingernail, letting the pointed tip of the nail lightly graze the puckered darkness of Tanja's areola, then spiraling around the darker oval of flesh until it reached the tender opening of the nipple itself. The sensation was so similar to what Tanja did with her own breasts while she was wet and slippery in the bath water, that she gasped from the feeling of deja vu. As if seeing that shock of self-recognition in Tanja's eyes, Ingrid whispered, "Were you and your little girl friend pulling the crotches up against your labia, or were you giving each other pussy-massages?"

Her face growing hot, Tanja lowered her eyes and mumbled, "Yes... with hand-lotion—" at which Ingrid laughed that throaty, purring chuckle of hers, as she reached down to lightly tickle Tanja's mound of Venus, until her fingers burrowed deeper through the re-grown

reddish mass of curls, and Tanja found herself gasping and panting as her roommate lazily circled her clitoris with a light, teasing motion. Tanja flipped on her back, arching up her pelvis as Ingrid increased the pressure on her clitoris while simultaneously rubbing the area in ever-widening circles, until the lack of stimulation on the sensitive nubbin of flesh made Tanja's thigh muscles quiver with excitement, but Ingrid's fingers grew even more coy, now drawing lazy figure eights along Tanja's entire labia, pausing briefly in the vagina itself, before arcing back to flick past the clitoris, then starting the cycle anew.

And, as if from a very long distance, she heard Ingrid's teasing voice ask, "Do you even miss the lotion?" and in answer, Tanja shook her head No against the pillow, sending her hair streaming out in ray-like strands of burnished red, while her belly and pelvis arched reflexively before Ingrid finally resumed the slow circling motion on Tanja's now blood-engorged organ, and Tanja felt the ripples of her orgasm envelope her, until the last of the ever spreading ripples washed from her consciousness, and she opened her eyes to see Ingrid propped up on one elbow next to her, her breasts shifting to one side like stacked pillows, while a wicked tight smile played on her lips.

"Was this better than little-girl rubbing? Little girls, they know only the tickle and the itch... a little scratch, a bit of rubbing, and it's all better," she cooed in that slightly mocking, yet softly tender voice, before she held her hand up, the fingers shiny in the room's dimmer-lowered lights, "And they need to add water—"

Coming back to her sense of self, Tanja chided, "I got wet on my own that time... my friend did, too... We weren't 'little,' either... we had hair and all—"

Ingrid laughed again, as she peered down at her own shaven mound, and the clear bubble of moisture welling deep within her; before her roommate could tease her again, Tanja added, "And I've been shaved... by my boyfriend. Before I did it to him."

Languidly rubbing her own bald mound, Ingrid asked, "And who liked it more? You or him?"

Taken aback by Ingrid's shift away from taunts about her lack of experience, Tanja found herself buying time by looking at their paired reflection (only their heads and the rising curves of their bare hips were visible from this angle) in the dresser mirror; she hadn't really thought about it that night, since she'd been so intent on not nicking or cutting Peter with his razor, but now that she really thought about the experience, it all came back to her:

Peter kept craning his head up, as she carefully snipped away the tufts of his light brownish hair, asking, "How close are you to the skin? Don't pull too tight... is there much left to go?" but she'd been too nervous to answer him, for fear of losing concentration and cutting his testicles or penis with the tips of the scissors, and once she'd shorn the longer hairs, he propped himself up on his elbows, until his usually taut stomach was a mass of rolls of flesh, so he could supervise the actual shaving, and even then, he kept up his worried stream of directions—"Not so much foam, be sure you can see the skin underneath... pull the razor with the grain... ouch, not so close... be careful, he's very attached to me... wait, that scrapes... there, you missed a patch..."

And afterward, when she had him in her mouth, and was rubbing the newly bare flesh around his member with her fingers, he chafed under her, until she had to stop and go get some lubricating jelly from the tube in his dresser drawer, and slather his shorn flesh until it glistened, and only then could she resume caressing his flesh with her tongue, but by then... all the orders and admonishments and requests had turned the evening somewhat sour...

"Well?" Ingrid was now playing with Tanja's breasts, cupping each in her dry-skinned palms, and squeezing them gently for emphasis, until Tanja admitted, "I did...

but I suppose it was because I knew he was used to shaving his own face—"

Ingrid's mouth puckered into a moue at that; releasing Tanja's breasts, she shook one finger teasingly in front of Tanja's face, as she said, "Since when does a man have a face contoured like a woman's pussy? No, you simply trusted him with your essence, while he feared for a slip of the razor. Do you think I let my boyfriend shave me? Even if there were no vaccine for AIDS, do you think I'd fear it if he cut me, or if I clipped him... blood is as natural as sex. Your boyfriend was obsessed with his own needs. Do you think you'd have enjoyed it more, shearing him, if he'd let himself enjoy it?"

Tanja merely blushed at that, remembering how she and Peter had stopped making love for as long as it took for their hair to grow back, as if their continued baldness was a reminder of that not-quite-perfect sensual experiment... but when she felt Ingrid's fingers caressing the coiled locks of hair on her mound, she placed a staying hand over Ingrid's and asked, "Why does what you do to me feel so much better than what Peter, or even my own hand does down there?"

Brushing off Tanja's hand from her own, before she resumed that exquisitely lazy circling and moving away motion, Ingrid smiled and said, "Because I know what feels good on me... and since you've got the same organs I do, it's like pleasuring yourself without bending your wrist in the wrong direction... besides, if a man did have a vagina, and a clitoris, and labia too, he'd better understand us... and vice-versa," she added, with a wink, before extracting a vibrator from beneath the covers.

Tanja stared at the peach-colored wand of plastic, which was covered with a disposable, realistically wrinkled sheath, and argued, "But it's not real," to which Ingrid replied, "But at least I know where it will feel best for you," before switching it on.

And, true to her word, Ingrid was able to position the

gently throbbing faux penis at just the right, clitoris-rubbing-as-it-entered-her angle, sipping it swiftly and evenly in and out of her moisture-sheened depths, then allowing the entire vibrating length of it to linger against her labial folds, before teasing it along the length of Tanja's belly, and under and around each breast.

Afterward, Ingrid whispered, "If a man were to try that, his poor back might break," before she handed over the still-quivering wand and a freshly opened sheath to Tanja, then flipped on her own back and arched her smooth-skinned mound toward Tanja's descending hand...

As she traced the tip of the vibrator against Ingrid's yielding flesh, Tanja let her own memories guide her (memories of probing fingers and penises wielded by others she'd thought knew more about pleasuring her by virtue of their imagined-to-be-superior looks, or supposedly superior sex), and—buoyed by a new-found sense of confidence—even added some variations of her own as she felt the throbbing motion of the plastic wand move along her hand and arm, then spread over her entire body; once she was through using the vibrator, she clicked it off, then ran her own tongue along Ingrid's slippery, musky folds, as she pictured her own freshly-denuded mons and labia under her own, flicking, probing tongue—and to hell with Peter, I don't need him to feel something this deeply, she'd mentally added, as Ingrid moaned, then shifted around under her, seeking out Tanja's own hidden inner softness—

When she heard the metal-against-metal zuuupt of the probes retracting back into the base of the recliner, Tanja opened her eyes... and immediately saw the glistening clear pool of moisture spreading out in front of her sensor-trailing vaginal area in the overhead mirror. And the deep, sated redness of her organs, and of her eyelids, was unmistakable... and utterly different from her previous Bio-donation sessions, the early ones during which she'd

allowed herself to be distracted by her petty, mostly self-perceived inadequacies. As if it were my fault, or Ingrid's, that she'd be better suited to flesh-sex for hire than I am... as if I should take personal offense that men like her Tech-date choose to only look at the outside of a woman. As if pleasure can't come in any package...

And she was both surprised/not surprised to see how mottled her breasts were, from kneading and rubbing them as she'd relived that first, pivotal lovemaking session with Ingrid, back in the days when times hadn't been quite so tight, and Ingrid had little need for seeking out flesh-sex buyers—or Tanja hadn't been so willing to take Ingrid up on her "you might not like it, but it is a job—and a good-paying one" suggestion. But times had grown so tight, and jobs were so scarce, and neither of their university-sponsored jobs were quite enough anymore... but that didn't mean that the roommates still couldn't make time for each other, outside sex-jobs or not—

Maybe next time, I'll ask her to shave me completely before we make love... or I do another Bio-donation, Tanja mused, with more eagerness on both counts than she'd ever felt before, as she sat up on the slippery recliner, and allowed her legs to meet for the first time in over an hour (the stiffness in her hips was still there, as usual, but then she remembered the pre-need-for-sex-selling time when Ingrid snuck her into the university dance practice room, where they'd done naked splits and leg-on-the-bar stretches in the drapes-drawn, mirror-walled room, and as much as her hips had ached after that night's lovemaking, she'd been eager to make yet another visit to that echoing, parquet-floored room), perhaps I'll even take her up on that offer to shear off all my hair... she's always teasing me about the "dots" on my scalp, even as she keeps assuring me that I do have beautifully-shaped head... no matter how much I tell her I don't...

Finally confident in Ingrid's assessment of her looks, Tanja was so absorbed in imagining what a complete

shaving session might feel like, how the weight of Ingrid's razor wielding hand would feel going over the lathered curves of her perfectly-shaped skull, that she almost missed the first subtle motions of the Syntho-Mate on her recliner... but when that unexpected movement appeared in the corner of her eye, Tanja found herself standing, still sporting the sensor-pads linking her to the 'Mate like multiple umbilical cords (only who was really born just now, you or me?), and staring mouth-agape as the gloriously golden-tressed Syntho-Mate slid her elegantly long, tapered fingers through and under the springy locks of her merkin-like mons, the fingers moving with exquisite slowness and purpose while the 'Mate's blue eyes were nearly closed in ecstasy, their lids just beginning to flush with a faint tinge of quite realistic red...

Watching the masturbating Syntho-Mate, as the newly Bio-donated construct took pleasure in herself, for her own sake, Tanja felt a glow of self-satisfaction ripple through her own body; for once, she felt like a total sexual being, one not dependent on mere looks (or her imagined lack of them) alone, or the reactions of others to her... she stopped feeling twinges of envy over Ingrid and her flesh-sex-buying "boyfriend" (who might very well be sitting on the other side of that one-way glass at this instant, not quite earning enough money to even afford a Syntho-Mate of his very own), for didn't Ingrid still seek her out, when all Tanja could pay her was satisfaction for its own sake?

And I finally passed that on to a Syntho-Mate... that thing in me that transcends the need for the exchange of mere money, she thought triumphantly, her face and body glowing from within with a sense of confidence and inner-peace she'd only felt in brief, incoherent snatches before... only now, Tanja knew that she could call upon this totality of feeling which transcended any single sexual act any time she so desired... and I even get paid for the pleasure of experiencing it. Before she pulled the sensors off her head and her mons, Tanja thought/told the Syntho-Mate,

Don't ever forget this... no matter what your owner expects of you... whatever you feel is yours, to keep. Remember, that's a greater gift than whatever you happen to look like... looks are only important as long as you have a mirror handy.

Then, hoping that the had-to-be-watching technicians didn't pay too close of attention to her as she exited the room, sans the paper drape she usually wrapped around her nakedness like a bath towel, Tanja made sure that she walked close enough to the Syntho-Mate to be able to surreptitiously run her own hand along the freshly programmed 'Mate's symmetrically-tufted mound of Venus—and see, out of the corner of her departing eye, the Syntho-Mate's lips turn upward in thanks, their motion mirroring that of Tanja's own smiling lips.

And as she dressed under the watchful eye of the dressing area attendant, Tanja was already looking forward to her next Bio-donation—and the fee she'd get for it (a fee far bigger than any flesh-sex Ingrid might hope to earn) was the last priority on her mind...

You were the first, she mentally advised the activated blonde 'Mate, the first of many, many more. I have memories to spare, and my future memories will be even better, because I know what I have to give others is well worth the receiving now... what I give is good for others, but even better for myself, and for remembering—

And all of you 'Mates will have forever to relive my memories and enjoy them, as you enjoy yourselves...

Strange Tricks
Dave Smeds

Beth sat in the service alley behind the casino and listened to the crickets fuck. The insects hid among the trash in the dumpsters and the paper littering the pavement. Earth crickets. God knows what starship or planetary merchantman had brought them—Las Vegas sucked up every stray, air-leaking derelict in the quadrant at one time or another, their pilots groping for that one big win that would pull them out of debt.

The chirping recalled genuine, feral sounds Beth had known back home. There weren't many traces of nature on this asteroid. Even the air and gravity were artificial. Beth came here a lot, to sit on the step outside the kitchens with her shoes off, and be alone.

The hiss of a van cutting off its air cushion broke her contemplation. Fresh pastries had arrived for the restaurant. Beth tugged a final drag from her cigarette and stood up. One of the bakery delivery boys wolf-whistled as she slipped back into her pumps. She shrugged. Looking was free.

She shot the bull with the cooks long enough to grab a maple bar from the incoming trays, and slipped out through the dining section. A bored cashier mumbled a hello as Beth went past.

She ignored the cocktail lounge. Too much competition, some of it by amateurs. And she never bothered with the casino floor. The assholes there were already making love

to the odds. She chose the second level lobby.

A likely prospect stood in front of the GALAC-ATTACK pod, blasting away small holographic opponents. Young, but the leather coat he wore looked like the real thing, and those didn't come cheap these days. Human, too, probably Terran. She wormed onto the stool next to him, and shoved a four-credit in the RACEWAY game.

She managed to crash all three of her ships inside of thirty seconds. "Goodness," she said, "guess I'm not too good."

Her boy kept staring at the projection, intent.

"Where're you from?" she purred.

A long pause. He still didn't look at her. "Earth. Houston," he said finally.

"Be in port long?"

He finished off a wave of alien ships, and glanced at her before new ones materialized. He liked what he saw. But he looked back and began hitting the firing button again.

He might play her kind of games and he might not, but she didn't have all frigging night. She slid her ass off the stool and resumed hunting.

In about an hour she nabbed a Reticulan. As she followed its twenty legs toward a hotel room, they passed by the Twilight Lounge, the best bar in the hotel. The husky figure of Tony, the club's bouncer, leaned against a dimly lit archway. Beth waved.

Tony glanced at the Reticulan and raised an eyebrow.

Beth and her client stepped into the elevator tube and tugged at the grips. Gravity forsook them. They floated at a leisurely pace up to the sixth level. Beth thumbed her nose at the security camera.

The room matched countless others in the hotel. She guessed she'd probably been to this particular one four or five times. She tossed her purse on the recliner.

"What'll it be?" Beth asked.

The Reticulan shifted its segmented body and lowered one of its antennae. "Please to inform monetary charges,"

the translator mechanism at its throat twittered.

"Depends on what you want, cookie," she said, "and how long you want it for."

The Reticulan seemed nervous. It was hard to tell, though. Eventually it stated its request.

"Oh, *that*," Beth said. "That's five hundred credits."

The terms pleased the alien. Beth accepted the fee in casino scrip and stuck it in her purse before she stripped.

She left the Reticulan as soon as it was over. Her trick lay on the bed, skinny multiple legs waving in the air, wallowing in post-orgasmic calm. She'd never seen one on its back like that before.

To make ends meet, she needed more work. She stopped by her room to spruce up, then hit the rounds again.

Two luckless hours later, she popped by the Twilight Lounge. Tony got her a drink.

"How'd it go?"

She smiled. "Oh, you know. Reticulans are really just big insects after all. Hot about pheromones and that shit. I guess touch doesn't mean much inside all that chitin."

"You mean he just wanted to smell you?"

"Yeah. That's all they ever want. I make like it's a big deal, and charge the usual. That's why I like Reticulans."

"I'll be damned." Tony sucked ice out of his virgin margarita, and dissolved it on his tongue. "Tell me something, Beth. Is there anything you won't fuck?"

She thought for a minute. "Well, yeah. I'm not in the business to get hurt. No whips, no chains, no spurs."

Tony shook his head. "Skip that type. I'm talking about species. Any intelligent extraterrestrials in the Galactic League you wouldn't do it with?"

"If their money's green, my pussy's pink."

"Even Sirians?"

"Sure."

"Jeez."

She sipped her drink. "I'd even fuck you, Tony."

He paused. "For free?"

"Hell, no. I'm a pro. But since you're nice I'll give you a twenty percent discount."

"No thanks," he said, though he was giving her a good hard look in the boobs. They were the kind that stood up to detailed examination. "I don't pay for pussy."

"I've noticed that. All the other girls think you're a saint or something."

"Principles. I don't waste money. The bar gives me free drinks, and even then I leave out the alcohol so I won't start thinking crooked. I don't do other shit, either. And if I can't find any free snatch around here, I can always get some from my wife."

"Why the tight pocket?"

"I got plans. Someday I'm gonna set up my own place. I'm sticking every extra penny into certificates and bonds. I got quite a bit put away."

"You have to indulge yourself once in a while."

"Not if it costs me." But Beth could tell he was tempted. She was one of Casino Luck's best assets.

It was while she was fucking a Rigelian that she got the idea. She was on her hands and knees, letting him bang away. Like most of his kind, he preferred dog-style. He could get both his pricks in without any trouble. Beth liked Rigelians. They had short ones that didn't jab her insides; she could fuck them all day. It was much better than having two men; she didn't have to worry about timing her rhythm to one and neglecting the other. As a professional, her pride suffered if she couldn't give her johns all the attention they'd paid for.

By the time he came, in alternating squirts that made her perineum quiver, she had worked out all the details of her plan. She finished up with him as fast as she could, barely giving herself time to let the come drip out before she dressed and headed down to the bar.

~

"Let me get this straight," Tony said. "You want to make me a bet?"

"That's right. It isn't proper to have all that money put away without risking a little of it."

"So you say. Run it by me again."

"If you can find an alien that I can't get off, you win. If I can make 'em all come, I win. You get four tries."

"And what do I get if I win?"

"You get to fuck me once a week for a year, free of charge."

"And if I lose?"

"You fuck me once a week for a year, but you pay."

"A little guaranteed income, eh? What are the rules?"

"The tricks can't know they're part of a bet. You choose the mark, and we'll set Joey the Pimp after him. Joey's smooth. He'll haul 'em in. If they're a tough sell, we offer me on the house. That ought to get them for sure. Or you can pick another one of the same race. If I find out you've set something up, the deal's off."

"Don't worry. But how do I make sure you've done your part?"

"I already talked to hotel security. They'll let you watch on the monitors. You can see their orgasms for yourself."

"Fair enough. Anything else?"

"No females. I don't want any arguments about whether they come or not."

"Right." Tony stared at the dainty nipples poking through her gown. "How do I know you're worth it?"

"Try me."

"Do you give free samples?"

"Nope."

He shrugged. "I guess I'll have to go by your reputation. Okay, it's a deal."

She had to give Tony credit. He didn't waste time with

easy ones. The first thing he did was send over a Sirian. She could understand his strategy—a cock three feet long and six inches in diameter could be intimidating. Still, she'd screwed her first Sirian at fifteen. Truth to tell, sometimes they were less work than human johns.

She had the concierge send up a massage table and oils. "Over here, cookie. Slap it down on this." The Sirian was already naked. He lifted his massive member and laid it on the table.

First she poured on the oil—lots of it. When she had him good and slippery, she began to knead him with firm, regular strokes, using forearms as well as hands. The Sirian's breathing deepened. Incredible though it seemed, his cock expanded. It never would become erect; nothing with that much volume could stand up all by itself.

Beth smiled up toward the smoke sensor. It hid one of the security camera lenses. All the rooms had several, though naturally the guests were not told about them. Hotel security at Casino Luck was a popular job.

Okay, Tony, watch this!

The Sirian arched his back, cock pulsing. She increased the rhythm and vigor of the stroke to as high a level as her petite arms could bear. He snorted like some big, extinct African beast. Just when her hands were ready to fall off, he fired.

The first wad thundered into the far wall, splattering thick blue semen over an area several feet wide. It hung momentarily, then gradually oozed toward the floor. The second and third sprayed globs over the carpet. Fury spent, the rest dribbled out onto the massage table, one wide strand hanging over the edge and gradually elongating toward the floor. Beth scooped it up in her palm and lapped it up. The Sirian loved it, though that wasn't why she did it. Sirian semen tasted good enough to be bottled. Poor Tony. How could he know?

The place was a mess, but that's what maids were for. Feeling especially smug, she invited the Sirian to the local

steakhouse for dinner. Tony'd have to dream up something harder next.

He did.

The next john was a Scythip, a twelve foot tall string of an alien. She'd fucked his type before, of course, but usually with another girl. That was the practical way. Scythips had a bit of a Linda Lovelace/Deep Throat problem. The spot that needed to be stimulated for orgasm to occur was about nine inches inside their mouths. When two Scythips copulated, they used their long tongues to get each other off. The penis needed its attention too, of course, in order to get an ejaculation, but to a Scythip teenager, "going all the way" meant French kissing.

Tony would never let her bring in another girl. She had to handle this beanstalk herself, despite the fact that his throat and his prick were a good five feet apart. It meant doing it the hard way. She shrugged and took him to one of the hotel's null gravity rooms.

The Scythip was happy to cooperate. They got into a sixty-nine position and tethered themselves together so they wouldn't float apart. She slipped him into her mouth— Scythips fortunately were not as incredibly long there as in the rest of their bodies—and inserted one of her feet into his snout. Then, best as she could, she wiggled her toe against the right spot.

It was awkward, but the absence of gravity made it possible for her to keep her leg constantly elevated. Luckily, his sensitive area was on the upper side of the throat; otherwise her toenails would have been a problem. Eventually she found the rhythm: down her throat, hold it a second, rub with her toe, out of her throat until the head almost left her lips, rub with her toe, down her throat again, etc. She didn't really have to worry about the exact movement, she kept her foot where it was and let the Scythip adjust the stimulation so that it suited him.

All at once, a potent, salty taste filled her mouth. She

lifted away just in time for Tony and the security boys to watch, catching the last streamer in the eye. She drooled out her mouthful over his spasming tool, maintaining her foot strokes until the alien himself stopped. She was bone tired, but every inch of her glowed with accomplishment.

"This one could get to like short females," uttered the Scythip's translator.

"That was pretty good," Tony admitted later. "You oughtta be in loops."

"Find me a producer and holorecorder," she said. "You wanna concede the bet now?"

He grinned. "No way. I got a Canopan lined up next."

"Oh, Tony, not a Canopan," she groaned. "Have a heart."

"Are you ready to give up?"

"No. I've done it with Canopans before."

"Prove it."

The problem with Canopans was not that it was hard to make them come. It was a question of what self-respecting human being would want to. Beth had told the truth; she had fucked Canopans before. Twice. The first time, she didn't know any better. The second time she agreed only because the trick was willing to pay a *lot* of money.

She found her client, sure enough, in one of the executive suites with the huge sunken bathtubs. He was a amorphous blob with a huge slit of a mouth and eyes that rested at the top of thin stalks, capable of being turned in almost any direction without any movement from the rest of the body. Somewhere under his giant rolls of fat, which hung to the floor, were his legs and genitalia. Beth didn't waste time. She lifted the living curtain and crawled into the foul smelling, and positively hot, cave of flesh.

She reached up into the mass of octopus-like legs and found the one that served as a sexual organ. It was a little thinner than the others. Trying not to breath too much of

the odor drifting out of the many holes above her head, she went to work.

It was a straight hand-job. That's all it ever took. He came in less than two minutes. Beth gritted her teeth and let it rain down on her—semen, urine, feces, and droplets of plain perspiration. That was how Canopans did it. When a male and female of their race got together, they tickled each other's things until they both emptied out of every passageway. The sperm and eggs would drop into the puddle of muck, fertilize one another, and the zygotes would feed off of the material, which the parents would replenish if they wanted children, or let dry if they didn't.

And of any bodily wastes that Beth had ever smelled, the Canopans had the worst. After all, that was all they ever fed on, their own and that of other species. She almost fainted before she had crawled out from under. Worst of all, everything was sticky. It would take her hours of showering to get rid of it all.

She couldn't imagine Tony playing much harder. But in spite of her disgust, she hummed a happy tune. One more trick, and she'd win the bet. He couldn't possibly come up with anything worse than this.

The next night, she entered the designated hotel room and found herself with a slender, dark-haired, completely human-looking young man. A handsome one, in fact. She checked the room number one more time.

"Hi, I'm Beth."

"I am Thamet," he answered. She could see a translator collar on his neck.

"What planet do you come from?"

"I am a Cassiopean."

She nodded. Not quite human, but damn close. She'd had dozens of them. She wasn't quite sure what Tony was up to this time, but there was only one way to find out.

"Okay, cookie. Get your clothes off."

He obeyed. In fact, that was the literal way of putting it.

He seemed, if anything, to be stripping simply because she'd asked him to. He stood in the center of the room waiting for her next order.

Beth tossed her panties on top of the rest of her clothes and sized him up. Good shape, well hung, healthy looking. His alienness showed in small ways. His navel was set too high; so was his rib cage. All in all, he seemed like an ideal john. Something was rotten in Denmark.

"Well, let's do it," she said spritely, and kneeled down and lifted his prick with her tongue. She let it idle there, rolling on a film of saliva, then slowly dropped it into her mouth.

It was warm and soft the way a cock should be, and it turned her on. Even after years of professional detachment, it still made her wet to suck a man. He got hard in perfect synchronization with her arousal.

She blew him for a while. When it didn't look like he'd come soon that way, she laid him down on the bed and climbed aboard. First she tried the traditional position, in and out with long, firm strokes, listening carefully to his breathing. It felt good to her, and obviously did to him, too, but he still didn't come.

She got into a squatting position and began humping him vigorously. She nearly slid off of him each time, then back down to the hilt, until his prick gleamed like a piston. She had never known any man able to resist that particular movement.

But Thamet did. He fucked her back as good as she did him, and still didn't come.

She switched around, facing away from him, and tried again. Hell, this position had worked on an eighty-year-old man. But all it did this time was wear out her knees.

She was getting frustrated. As the mood grew, Thamet became more flaccid.

Thinking maybe he was the type who had to be in control of the rhythm, she let him be on top. He didn't seem to care. Whatever she asked, he did. But he seemed to be

sincerely trying. She forced herself to relax. Everything would be fine. Some boys just took time, that's all. She would be patient. There, he was enjoying himself more already. She squeezed back. He got harder.

"That's it. Keep doing it, cookie." She encouraged him all the ways she knew how. They humped until she was sore. In the end, nothing worked. She dried up. His erection withered.

"Shit, Thamet," she said, flopping back on the mattress, feeling like she'd never walk straight again, "you're going to cost me a lot of money."

"Why?" he asked, lying beside her. He seemed equally weary.

"Never mind," she said. She glanced forlornly at his limp meat. "Tell me, Thamet, how do you do it when you're alone?"

"Do it?"

"Have an orgasm, I mean."

"I don't. I only feel like having an orgasm when I am with someone."

She blinked, fingers halting midway through untangling her sweat-matted hair. "Don't you feel like it when you're with *me*?"

"No. I almost did earlier. But the urge went away. Now I am simply tired."

"Oh," she said, and put the pillow over her head.

"All right, Tony," she said piquishly over their table in the Twilight Lounge. "It was a set-up, right? You found a guy with a dysfunction of some sort."

"Nope," he said amiably. "He could get off just fine. You just didn't use the right technique."

"Oh, come on. What does it take? I've screwed lots of Cassiopeans. None of the others could ever hold back."

"You haven't ever screwed this type before. He's a special breed."

"How's that again?"

Tony smiled impishly. "About five per cent of all Cassiopeans are like him. They're empaths. They absorb other people's emotions. In fact, they hardly have any of their own. They just reflect the states of mind of the people nearest them. Joey the Pimp had a real easy time bringing him in. Thamet would have done anything you wanted, as long as you could make him feel it. All you had to do to make him come was to climax yourself."

The truth began to knock painfully against her skull. "That trick was a trick! Dammit, I can come any time I want."

"But with Thamet, you were concentrating too hard on your work. You didn't take the time to get off yourself, so neither did he."

"That wasn't fair play, Tony."

He leaned back, pretending to be insulted. "Sure it was. I took a hell of a risk. If you'd just asked Thamet how you could get him off, *he would have told you.*"

"But I—" Beth stammered. Her raised hand paused in midair. Tony was right. She hadn't ever actually asked Thamet that in so many words.

She'd been beaten, and by the rules. Any more protest wouldn't be professional.

She sighed. "Looks like you got yourself fifty-two free fucks, Tony."

But one thing was certain, Beth thought as they walked up to one of the nearby rooms (where Tony casually blocked off all the security cameras), for every one of these fifty-two times, she knew who was going to come *first.*

Chance Encounters Inc.
Evan Hollander

"Welcome to Chance Encounters Inc. Mr. Attwell. I'm Roland L. Fournier and I'll be acting as your caseworker," the man said, opening his arms wide in a welcoming manner. He was a tall man, with thick wavy hair and a neatly trimmed black mustache. He was dressed in a blue spandex leisure suit that followed each ripple of his muscular body. "Let me begin by saying you've made an excellent choice in coming to us."

The two men shook hands and Harvey Attwell winced as the strength of the other man's grip crunched his fingers together.

"Have a seat, Mr. Attwell," said Roland, gesturing to a neon-trimmed chair in front of the desk that was nothing more than a flat surface set atop a Z-shaped stand. "Care for something to drink? A coffee perhaps?"

"A coffee would be nice," Harvey said, moving to the chair and sitting down.

Roland pressed a button on a small console to his right and mumbled something into the microphone.

Harvey swallowed, licked his lips, his mouth dry as parchment, and wiped his sweaty palms on his cotton-polyester pant legs.

He knew they were doing everything to make him feel comfortable, but Harvey couldn't help being a little nervous. And who could blame him? It wasn't every day that someone admitted they were desperate enough for sex to try it with a machine.

But they're not really machines, Harvey reminded himself. Androids look so human these days that you really can't tell the difference anymore.

Roland must have sensed Harvey's nervousness because he flashed him a warm smile. "Relax, Mr. Attwell. I can understand your apprehension, but believe me when I say this—there's absolutely nothing to be worried about."

The office door slid open and a tall lithe redhead came in with the coffee. She was dressed in skin-tight crimson spandex that hugged her every curve. The outfit's neckline plunged all the way to her navel and her full round breasts created a long thin line of cleavage where the two orbs met.

"Do you find her attractive?" Roland asked, noticing Harvey's appreciative gaze.

"Why I uh... I uh... yes, I do."

The woman put the tray down on the desk and spun around to face Harvey.

"Come now, Mr. Attwell. No reason to be shy or nervous. There's nothing wrong with appreciating beauty, especially when it's so easy to appreciate." Roland made a gesture with his right hand and the woman spun again as if modeling a new gown. After two full rotations, she left the room.

"She was beautiful," Harvey admitted, a little out of breath.

"Perhaps you mean, it was beautiful," Roland said, his eyebrows arching up in tight curves.

"I don't understand," Harvey said.

"No. Of course you don't. It's hard to tell the difference between one of our androids and a real woman. And, of course, that's precisely the way our customers like it."

"You mean... that was..."

Roland nodded his head and smiled. "An android. You'll excuse our use of trickery in your introduction to them, but we've found that seeing one in a real-life situation first goes a long way toward breaking the—for lack of

a better word—ice."

Speechless, Harvey reached across the desk for his cup of coffee and drank it black.

"So," Roland said. "Now that you've seen the excellent quality of our product, we can begin the selection of your chance encounter. Come with me."

Harvey gulped down the rest of his coffee and followed Roland through a door at the back of the office and down a long curving corridor. They passed through several sets of sliding doors until they came upon a room whose walls were covered by computer panels, digital readouts and dozens of video display terminals and screens.

Harvey craned his neck in awe of the room's decor while Roland strode to a control panel on the far wall. Once there, his fingers clicked over a computer keyboard as he put information into the company's computer.

A panel-sized screen on the left-hand wall slowly came on. The Chance Encounters Inc. logo appeared in the top left corner, a model number appeared on the right. In the center floated the holographic image of a woman. It revolved so that the three dimensional image could be seen from all sides.

She was naked, and she was gorgeous. But, Harvey decided, a little too skinny for my tastes.

Roland gestured to the padded recliner positioned opposite the hologram. "Have a seat, Mr. Attwell," he said.

Harvey sat in the chair and eased it back; it was unbelievably comfortable.

"Now, I know you're familiar with our operation," Roland continued, "but federal law stipulates I go through the contract with you one more time before we begin."

Harvey nodded.

"You may choose any one of our twelve standard designs—that's our number six on the screen at the moment—but your file indicates that you've already paid the premium and would like to custom design your own chance encounter. Once again, Mr. Attwell, may I say

you've made an excellent decision."

"Thanks," Harvey said, smiling.

"Now, we will be inputting the datanet that our technicians will use as a guide to the design of your chance encounter."

Roland's voice went flat as he read the terms of the contract. "In exchange for the prepaid sum of $12,000, Chance Encounters Inc. agrees to have our android enter your life by some chance encounter within three weeks of today's date.

"Our android will not reveal her identity to you in any way during the encounter, but you have the option of having her reveal it to you by asking, 'Is this a chance encounter?' To which she is programmed to respond by saying 'Yes it is.'

"We guarantee our droids against mechanical failure and the transmission of all communicable diseases. We also guarantee total satisfaction or your money refunded.

"Do you understand the conditions as I have read them to you?"

Harvey nodded.

"Please respond vocally for the audio recording of the contract."

"Yes, I understand."

"Excellent, Mr. Attwell," Roland's voice automatically brightened. "Do you have any questions before we begin?"

"I wanted to ask you about repeat encounters."

"Yes, of course. We do offer repeat encounters at a discount which increases with each subsequent encounter, but this part of our operation is being phased out and will be terminated by the end of the year. We've found that what our customers lack most is confidence with women. A chance encounter gives them that confidence and as a result they usually don't require our services a second time. Besides that, it costs us more to keep a droid in storage waiting for a repeat encounter than to send it back to the shop to be refitted for another customer.

"But enough technical business, shall we begin?"

"Yes."

"Skin color?"

"White."

"Hair?"

"Black."

"Eyes?"

"Green."

"Build?"

"What do you mean?" Harvey asked.

"Do you want her to be thin or plump?"

"Does it have to be one or the other?"

"There are degrees to each."

"I'd like her to be somewhere in the middle, but more plump than thin."

"Fine," Roland said, his tone of voice professionally patient. "Measurements?"

Silence.

"Measurements, Mr. Attwell?"

Harvey remained silent. Although he knew what he wanted, he squirmed in his chair, embarrassed by his own desires.

"Come now, Mr. Attwell," Roland said reassuringly. "You've paid a considerable amount of money to get exactly what you want and there's no reason in the world why you shouldn't have it." He paused a moment. "Now, Mr. Attwell. Measurements?"

Harvey closed his eyes and writhed in his chair, at last he spoke. "Forty-four, no six... Forty-six. Twenty-five... Thirty-four, no, thirty-eight. Yes. That's it. Forty-four, twenty-five, thirty-eight."

Roland tapped the information into the keyboard. "Excellent, Mr. Attwell."

It took them another hour to finish constructing the datanet. Everything from eyebrows to fingernails were decided upon until Harvey Attwell's dream girl was complete.

"She is magnificent," Roland said, tapping the final bits

of information into the computer. A hologram of Harvey's
dream girl rotated on the small screen in front of him. "I'm
sure you will be pleased."

"May I see?" Harvey said, a shy little tremble in his
voice.

"No!" Roland said, flipping a switch at the side of the
terminal. The hologram slowly faded. "If you knew what
she looked like, Mr. Attwell, you wouldn't have much of a
chance encounter now, would you?"

Harvey climbed out of his chair. "No, I suppose not."

Roland escorted him to the exit. "Remember, she will be
coming into your life in the next three weeks. Be ready."

"I'll keep my eyes peeled," Harvey said.

"Don't worry Mr. Attwell. Looking for her won't help
you one bit. Our company's not called Chance Encounters
Inc. for nothing."

Harvey nodded. "I guess so." He turned to leave.

"Good bye, Mr. Attwell. Enjoy."

If the truth be known, Harvey Attwell wasn't what peo-
ple called a ladies' man. He was more of a monosyllabic
kind of guy to which the words geek, nerd and spaz were
more accurate descriptions.

And even though he was a wealthy man—the royalties
to several of his computer game designs bringing in a gen-
erous annual salary—he was never able to be as comforta-
ble with people as he was with machines.

But that was all changing.

He knew he'd be having his chance encounter soon, but
he had no idea when it would come. As a result, he was
alert every waking moment, peering around corners and
sizing up each and every woman he saw.

There was an excitement to be had in the knowledge
that the woman of your dreams could drop into your life
at any moment. And, Harvey was happy to note, the fact
that she would be an android and not a real woman, didn't
seems to make that much of a difference. Just knowing

he'd be meeting and sleeping with a feminine goddess of his own design did something to Harvey—it gave him the confidence to approach women that normally scared the shit out of him.

He'd been on the lookout for close to two weeks without any luck when out of the blue on Wednesday afternoon he saw her.

She was sitting alone on the subway. She was dressed in dark green spandex and she was everything Harvey had dreamed she would be. She was slightly on the plump side, but voluptuously so. Her hair was black as night and made her skin look as white as alabaster. Her figure was incredible and there could be not doubt she measured the 44-25-38 Harvey had asked for.

As the train pulled out of the station Harvey saw the empty seat to her right and had to fight off the urge to rush up to her and sit down and ask, "Is this a chance encounter?" But he steeled himself for a slow approach, not letting the rocking of the subway break his calm, confident stride.

"Is this seat taken?" he asked, flashing a small smile.

"No," she said in a husky voice.

The voice is a nice touch, Harvey thought as he sat down beside her. His eyes wandered over her curvaceous form, stopping for a moment to notice her nipples denting the spandex that swelled to contain her magnificent chest. He also noticed her eyes. Beautiful, but in the artificial subway light they looked more blue than the green he'd asked for. Oh well, he thought. I suppose I can live with that.

"My name is Harvey Attwell," he said, offering his hand.

For a moment the woman looked at him as if he'd just dropped down from another planet, but she extended her hand. "Grace," she said. "Grace Beatty."

"Pleased to meet you," Harvey said as they shook hands.

There was an awkward silence for several moments as

the subway rounded a corner and came out into the open. Sunlight burst in through the windows and in the new light the woman looked even more desirable in Harvey's eyes.

"I must say," Harvey said, an uncharacteristic wave of bravado overcoming him. "You have the most magnificent pair of breasts I've ever seen."

A look of shock burst upon Grace's face and she raised her hands over her chest.

"I bet they're absolutely stunning when you're naked." He smiled, thoroughly enjoying the encounter. It was all so unlike him to talk to a woman like this. Grace's shock eased into a look of curiosity as Harvey continued talking.

"And the way you dress, I can tell you're proud of your body. And well you should be. Too many large-breasted women are ashamed of the way they look and they dress down, try to hide what they are. I think a body like yours is a real turn on, something to be admired and revered."

Grace leaned forward and shot a glance at Harvey's crotch. He'd recently turned in his cotton-polyester mix for more fashionable spandex, and the stretch of the form-fitting clothing proved he was telling the truth.

Harvey looked at Grace and noticed the dents of her nipples were more pronounced than they'd been a minute before. He made a note to commend Roland on the company's attention to detail.

The subway began to slow as it pulled into the next station. Grace got up to leave. Harvey got up as well.

"Are we getting off here?" he asked.

Grace looked him over, head-to-toe several times before her eyes finally stopped at the throbbing bulge of his crotch.

"Sure, why not," she said. "Come on."

Grace moved quickly through the crowded downtown streets and Harvey had a tough time keeping up, until they arrived at a modular apartment complex behind a pair of skyscrapers.

"Nice building," Harvey said, as they stepped onto the elevator.

Grace pushed twenty-five and they began rising up on their way to the twenty-fifth floor.

"I just live a couple of blocks from here," Harvey said, looking out through the glass at the shrinking cityscape below.

Grace turned to face him. Her lips parted slightly and she passed her tongue over them, leaving them wet and slick in the day's fading twilight.

Harvey heard a zip and a moment later felt Grace's huge breasts pushing against his face, smothering him. As he guided one of the swollen nipples into his mouth, he could feel hands gliding over his body in every widening circles until the hands came to rest on the junction of his legs.

Just then the elevator stopped and the doors opened onto the twenty-fifth floor. Without covering her exposed chest, Grace stepped out of the elevator and guided Harvey down the hallway, her hand firmly wrapped around his bone-hard member.

She put her right hand over the Palm-Print lock panel on the door frame and the door slid open.

Inside, Grace stripped out of her clothes and then did the same for Harvey.

They stood before each other for a moment and Harvey said, "I was right. They're absolutely stunning."

"Thank you," Grace said, acknowledging the compliment by massaging her breasts and tugging on the nipples as if the action might make them grow even larger. "You're not so bad yourself," she said, looking down at Harvey's erect and bobbing cock.

"Really?" Harvey said, "Uh... I mean, thank you."

Grace turned, showing Harvey her plump but firm behind. She walked away from him, her hands rubbing her asscheeks and her fingers pulling the flesh aside to show him that her love hole was glistening with moisture.

"Now, let's see what you can do with it." She continued on into the bedroom. Harvey watched her for a moment and then ran after here, his cock waving in the air like a flagpole in a hurricane.

When he got to the bedroom, she was already kneeling on the bed, her pelvis grinding in long slow circles as she fingered her clit.

Harvey walked up to the bed, his cock bobbing with each step. He stopped at the edge of the bed where Grace caught his swaying cock in her mouth and began to suck.

Harvey threw his head back and gave out a long soft moan. It felt as if she were sucking cum up from the soles of his feet, but even so Harvey still had the presence of mind to bend over to cup her hanging titflesh in this hand and massage her magnificent jugs.

Grace responded to his touch, pumping her mouth up and down more feverishly on his pole for a minute before shifting around to sit on the edge of the bed. She was facing him now and continued to lick and suck his manhood, stopping the pumping rhythm of her mouth every now and then to slide his slick pole into the valley between her breasts for a titfuck.

The sensation of being titfucked by the woman of his dreams put Harvey on the threshold of a monstrous orgasm. He could feel his knees getting weak and his throbbing cock was aching to be allowed to explode.

He lowered his head and saw his gleaming shaft sliding between those two magnificent orbs of flesh. It was more than enough to put him over the top.

He began thrusting his cock against Grace's chest to which she responded by squeezing her tits more tightly together. His cock began convulsing and a moment later streams of cum began creaming all over her tits.

When it was over, Grace lay back on the bed and began rubbing her breasts, massaging his cum over them like ointment.

Harvey staggered for a moment before falling forward

onto the bed and landing by Grace's side. He closed his eyes to sleep.

"Now you hold on a minute," Grace said, getting up from the bed. "You're not done so easily, my friend. We've got a long way to go before we even think about getting some sleep." She took Harvey's hand and dragged him off the bed and into the bathroom.

They showered off. Harvey found he liked the taste of Grace's warm wet cunt and he made her come twice before they fucked under the pounding water of the showerhead.

Back in the bedroom they fucked again, trying as many different angles and positions as they could think of.

Finally, Grace gave Harvey one last titfuck and they called it a night at two-forty-six in the morning.

Harvey crawled out of bed four hours later.

As he got dressed, he looked down and saw Grace sleeping silently on the bed. He saw the rise and fall of her chest as she breathed and wanted to have one last fuck before he left. But he looked over at his limp cock dangling between his legs and knew that sex was out of the questions.

They guaranteed total satisfaction, he thought, and they delivered.

He gave Grace a quick peck on the cheek and left the apartment headed for his own. He had an important meeting at nine that morning and wanted to go home for a change of clothes before going to the office.

As he rode the subway the few stops to his apartment building he couldn't help but feel happy he'd gone to Chance Encounters Inc. Sure, it had been expensive, but it had been worth it. The sex had been so good, so fantastic, that he couldn't imagine it being any better, even with a real woman.

As he got at off his station, he considered paying for a repeat encounter. The thought made him feel warm inside, especially down there.

When Harvey reached his apartment he placed his hand over the Palm-Print lock panel and his door slid open. He was about to step inside when he noticed something in the corner of his eye.

He turned to see what it was: a woman coming down the hall toward him dressed in a pink terry-cloth bathrobe.

"Here kitty," she said. "Here kitty, kitty."

As the woman approached Harvey he noticed that her coal-black hair and fair white skin were quite attractive. It was hard to tell because of her bathrobe, but it looked to Harvey that she had quite an impressive figure underneath.

"Can I help you at all," Harvey said as the woman neared.

"I've lost my kitty," she said, coming to a stop in front of Harvey.

Harvey looked into her eyes—they were green. Just then, the woman's bathrobe came undone and he could see that her figure was not merely impressive, but absolutely perfect.

"Is this a chance encounter?" Harvey asked, his heart slamming up into his throat like a thunderclap.

"Yes," the woman said. "It is."

Harvey spun around on his heels and ran down the hall. If he hurried, he might just make it back to Grace's place before she woke up.

Touch Me
Yvonne Navarro

"Somebody's touching me," Noelina complained.

I glanced sideways, a quick one. God, she was so beautiful it made my eyes ache to look at her for too long. Of course, with my bleary, lens-dependent vision, it made my eyes hurt to look at anything too long. What a lovesick jackass, I thought.

"I know what you're thinking, and you got it all wrong. It ain't like when I'm under the lights, you know? Sure, I've got some jamoke pouring chocolate syrup on my tits while he's poking me and I'm supposed to act like this is one great time, right, while all the time I got p.a.'s pulling on my ankles and telling me to spread 'em a little wider or lift the hips more, wouldja? That ain't a good time, Ernie, that's *work*. Hell, you oughta know that work ain't fun, right? It ain't *supposed* to be, no matter what people say—leastways not for the ladies. Why, I bet I ain't had an orgasm in two years." She looked triumphant.

Well, Noelina had me there. I was just assistant director, a nice title for the most blameable guy on the set—running errands, getting coffee and bringing film to the stills photographer (and wasn't he running right through the black and white lately?), making script copies, finding out what the hell happened to so-and-so's costume or pawning these jobs off on a production assistant in the rare event we could actually afford one. She was right on the money—*what* money?!—that it wasn't fun. My job anyway, and maybe hers, too. But what about the guy lapping up that chocolate syrup? I tried to keep my eyes from dipping into the cleavage that smiled sideways at me from the neck of

her robe. I wondered again what a partner-induced orgasm felt like; fog rolled across my vision and it took a couple of blinks before I realized it was Noelina's cigarette smoke.

She leaned across the table and looked at me intently above the top of her empty coffee cup. "It's like somebody's making love to me," she confided. "Never on the set, or while I'm at work, but...." She glanced away, her expression dreamy. The skin of her round face was white and fragile and made her look like some kind of plump china doll, moreso when those long, dark lashes lowered slowly over clear, lapis eyes. For a second she seemed to be reliving something private, then she recovered. "It can happen anywhere else, though—even the grocery store once—and always a couple of hours after we wrap up for the day. It's the damnedest thing, you know?"

"But I th-thought you said you'd never had an or-org—"

"An orgasm," she said helpfully. My face went scarlet; shit, I couldn't even *say* it. "And I didn't say never, silly, I said in two years, give or take a month." She made a soft blowing noise through pink, heart-shaped lips and I squirmed. "But I'm getting close, I'll tell you. And the weird thing is, I can't see who's doing it!" She shuddered, then glanced at her watch. "Oh my, only ten minutes before the retakes. Be a sweetie and get me another while I go to the bathroom, okay?"

I nodded and grabbed her coffee mug, pausing to watch her stroll to the door marked "Noelina" next to a tacky, peeling plastic sticker that used to look like a red star. The robe she wore hit the floor before the door swung all the way shut and I got a generous glimpse of her smooth backside and thighs before my view was cut off. Had she done it on purpose? Not likely; besides, even as busy as the set kept me, I got plenty of eyefuls of Noelina's naked body, though unfortunately most were while she was coupling with some well-hung actor who looked like he'd stepped

out of a hardbody underwear catalog. I snorted in disgust and pushed up my glasses as I went for her java; all I wanted in the world was a chance to... what? Touch her, maybe. And now she thought someone else was doing just that. Shit.

After I brought her coffee, I hit the set to see what was needed before they started the retakes. It wasn't long before I was up to my ears trying to find two extension cords, where's the costume that was used in Scene 18, and has anybody seen that extra who played the peeping gardener in the first four shots? And wouldn't you know it, here comes that photographer again.

"Ernie! Hey buddy, where've you been? I gotta get some more film." Matthews struggled with a complex-looking Nikon while three different lenses tangled on straps around his thin neck. I swear, the guy looked as pitiful as I did.

"I've never had a still shooter use as much film as you," I complained. "Not even *half* as much. What're you doing with all these photos, anyway? Butch won't buy 'em— you'll be lucky if he picks up seven or eight dozen. You're wasting your time."

"Come on, Ernie, give me a break. You're the only one with the key to supplies, and I can't afford this stuff on my own, not on the salary he's paying. Another one, okay? 1000 speed."

"All out of 1000 speed," I said promptly. He looked stunned. "If the roll in that camera is what I gave you this morning, that's it. No more until next Tuesday."

Suddenly his skinny fingers dug into my upper arm and I stiffened and glared at him. He let go and glanced quickly at his own hand, as though making sure it wasn't dirty. "But it's gotta be 1000 speed, Ernie, otherwise it won't work! Butch must have some stashed someplace. Did you check with Shirl—"

"Otherwise *what* won't work?" I demanded.

Matthews looked flustered for a moment. "The

developer, that's all. It won't do right with lower speed film."

I snorted, trusting that this was one of the few people at my job who would never think to make fun of that stupid, horse-like sound that had spilled from my mouth for most of my life. "That's bullshit and you know it. What're you trying to pull?" I shook my head. "Doesn't matter, anyway. We're out and I ain't got time to make an off-set run. You're just gonna have to control that trigger finger and stretch what's in your box."

"Ernie, please—"

Jesus, I couldn't believe it; the guy was *begging*, actually putting out a hand towards me. What'd I look like, a Fotomat? "Lookit," I said patiently. "I just can't go right now, okay? If you're that tight for it, I'll go down the block after the retakes, buy it with my own money and get reimbursed later. But that's the best I can do." So I was a white knight once in awhile. What can I say?

Matthews looked relieved, like a junkie who knows a fix is coming in another hour. He nodded so fast I thought his head (and yeah, I marvelled, I'd been right in once telling Noelina that I thought it was a little pointed) would jump off his shoulders and start spinning like a wind-up top. "That's great, man, just great. I can't thank you enou—"

I walked away while he was still burbling and managed to get up front without anyone needing an errand boy just as Butch was yelling "Action!" On the set Noelina was poured across a hot pink quilt that made her look like she'd spent all day basting in the sun. And she was cooking all right; the scene, another of Butch's great and sorry "originals," was a rich business woman parlor-fucking her butler while the gardener (who'd finally shown up) peered lasciviously through the window. Noelina looked out of place in a blue suit and white blouse, even with her knees all hiked up to show that blonde little place I liked to call "Heaven's Gate" in my solo fantasies. Speaking of

fantasies, what she was doing with her mouth on that actor was torture enough, but watching that guy's hands wander over her beautiful body made my breath stutter. It brought back what she was saying earlier about feeling "touched" herself, and I couldn't help but envy the unseen owner of the hands that got to play on her outside of the studio. Through the whole retake Noelina had that special, spoiled-little-girl-look that had made her videos such a big hit on the porn strips, but I kept seeing her earlier expression, that dreamy but not-quite-satisfied smile. More than anything, I wanted to be the guy who put the finish on that.

I was on my way home when I realized I'd forgotten all about my promise to Matthews. "Son of a bitch," I muttered and checked my watch. It was late by my standards, almost a quarter to eight and I had to be at the studio for the editing session at seven, but a promise was a promise. Besides, what'd I have to rush home to? A two-room apartment cluttered with old stills of Noelina (shot by a bunch of faded away, zero-talent camera toters), a television that was slowly fizzling out and a fat, smelly alleycat named Braindead that wouldn't have anything to do with me. Might as well hit the all-night supermarket and cut over to the photographer's. Same neighborhood anyway; Matthews's career was just as sparkling as mine and he lived only four blocks away.

He pressed the buzzer before I finished the first ring, like he was hanging by the bell and waiting. Long and loud, the sound rippled through the silent, musty hallway like a shrill phone in the middle of the night; I couldn't wait for it to end and that idiot seemed like he was going to lean on it forever. Jesus—was he trying to wake the whole building or what? I was rounding the third floor landing before the buzzer finally stopped and I could suck a breath past the knot in my chest.

Matthews was waiting just outside his door, fingers

twiddling nervously. Above the odor of developer, the smell of hot coffee wafted through the crack and sailed under my cold nose. "Hey, Ernie, thanks. You're a life saver, man." He reached for the bag, his eyes eager. When he had it in his hands he turned and touched a finger to his forehead like he was saying good-bye and tried to slip back into the apartment. I couldn't believe it—not only had I gone almost a mile (round trip) out of my way in the dark for this asshole *and* put out my own money for his film, but the bastard wasn't even going to offer me a cup of coffee! I might be lord of the gofers at the studio, but no way would I stand for this crap on my own time.

"Hey," I protested. "I could use a cup, you know? It's a long walk home and it's cold." I sniffed the air pointedly.

His expression went from grateful to apprehensive in less than two blinks. "Inside?" he squeaked.

"Where else?" I retorted. "I didn't see a cafe in the lobby. How about it?" If he refused I was gonna yank that bag out of his chemical-splattered paws and go home. The thought must've shown on my face because Matthews swallowed and reluctantly opened his door.

"Sure—I mean, I can hardly refuse, right? Here you went to all this trouble to get me some film—" He rambled on as I followed him inside, with him glancing around the whole time like I was a kid and he was making sure he had all the important stuff out of reach. There wasn't much to see and I couldn't figure out why he was so nervous, other than the place was a worse rathole than mine. But I hadn't expected anything anyway, so what was the problem?

"Nice place," I said automatically when he stopped in the middle of a living room that was so cluttered it looked like the forgotten storeroom of a museum for nonsensical photographic art.

Matthews gave me a lopsided grin. "Yeah, well," he managed. "You know how it goes."

I had to laugh—hell, I sure did! With the atmosphere warmed a bit, he left me to study the living room and

disappeared down the hall, presumably into the kitchen to fill two mugs. I glanced around the room curiously and my eyes stopped on a door sandwiched between an over-loaded bookcase and a leaning stereo cabinet propped up on one side with a brick that didn't look in much better shape than the faulty cabinet; above it was an unlit, jury-rigged red bulb hooked to a cheap wind-up timer that had seen a better life. As I watched, the timer moved its final notch and gave a low, defective *pung* that was a long way from the intended bell. I wondered what the hell he was timing.

"You want cream?" Matthews called. "I got generic."

"Yeah, load it up," I answered. "Can I go in and look at your shots? They're the ones from today, right?" Unless he'd been lying, he had no money to be doing any side projects.

That boy came running so fast you'd have thought the hot coffee was spilling down his pants instead of splashing from the mugs he clutched. My hand was turning the knob when he cried, "Don't go in there!" and skidded to a stop, nearly upending the brew on my jacket as he pushed the coffee at me.

I ignored the drippy mug and frowned. "Why not?"

"New, uh, type of film, that's why." He turned and set both mugs on top of the turntable cover, where they slid for a nerve-wracking two inches before stopping. "Yeah, weird shit. It's gotta process for twenty—uh, I mean, forty-five minutes extra in the developer to come out right."

I thought my eyebrows would lift right off my forehead. "I never heard of such a thing. What's it called?"

"It's, uh, it's—" He shrugged. "Can't remember. I picked it up while I was in Streeterville last month. Couldn't even tell you where I bought it." His eyes shifted to a battered institutional clock on the wall that looked as though it'd been salvaged from a school fire. Jeez, even I wasn't that bad. As he watched, the second hand labored forward with a strained twitch. "How's the coffee?"

I grinned to myself; already the lying bastard was getting desperate. If he had film in the developer pan, how'd he get out of the darkroom without a light leak to begin with? "It's great, man. Maybe I'll have another before I go." I raised the mug and took a small sip, then centered it carefully within the wet ring on the turntable cover. The seconds ticked by, each step of the clock's second hand making a sound like a fingernail flicking at dry skin. I watched his face; any moment now...

He broke. "I think I'll check the film." He fumbled with the doorknob and I couldn't resist putting a hand on his arm.

"Wait! I thought you said it needed an extra forty-five—you'll ruin it!"

"Wrong roll," he sputtered. "I just remembered I used normal film, not the special stuff. I kept that extra-develop roll aside 'cause I never have time to fool with it." I almost laughed out loud at that one; instead I followed on his heels, a helpful expression on my face as he pulled the door to then found the light switch.

"Well, I'll be double damned," I said in awe.

Black and white shots of Noelina lined every inch of the walls, some overlapping more than a few edges as each print was added to the confusion. But that wasn't what stunned me; all those pictures of the woman I adored were about as useful as pre-liberation maps of the Soviet Union compared to the prints that Matthews was carefully pulling out of the fix and dipping into the rinse. These were... they were...

Moving.

Sort of. And sort of not. They weren't flat, ordinary photographs. They were... *three-dimensional*, like the hologram special effects in science fiction movies. I guess the figures in these photographs didn't so much move as vibrate, like there was just enough life there to make 'em jiggle, but not enough to break free of the paper. Matthews kept dipping his tweezers into the wash before turning and clipping the

shots to line dry, then starting everything over again, never looking at me or saying a word. It was easy to see the guy was scared shitless, though I couldn't figure out why. Then it dawned on me.

Somebody's touching me.

"You slimy piece of dogshit," I said.

Matthews coughed and ducked his head. If it got any lower on his shoulders, I swear he would've turned into a turtle. Then, quick as a wasp, I caught his sly glance before his eyes widened in faked innocence. Great, I thought. Here it comes, the old change in tactics.

"What?" he asked, bewilderment plastered across his face like a poorly fitted ski mask. "What's the matter? They're only an illusion—"

"Don't bullshit me, Matthews." I stepped towards him and he flinched, his routine already disintegrated. "How'd you learn to do this? What is it, something you do to the film or your camera? You tell me, you sorry geek, or God help you I'll tell Butch you're taking and selling pictures of Noelina without her knowing it and he'll have your fingers broke so bad you'll never push a camera button again."

The photographer's face went white. "Oh now, hey," he pleaded, "I never meant no harm. They're only pictures that came out fucked up, that's all." He pointed to the developer pan, his movements almost frantic. "Hell, I ain't no chemist. I didn't even pass eighth grade biology. Found the shit by accident, that's all, when I spilled some no-name brand sodium thiosulfate into the developer instead of the fix. I didn't have the dough for more developer, so I tried it anyway." He spread his hands. "This is the result." He pointed to one of the shots hanging above my head. I followed his finger automatically and my nose almost ran into the trembling mini-expanse of Noelina's left hip. I groaned inwardly and looked away.

"What's the big deal? Fucked up shots, that's all," Matthews repeated. "Who cares?"

I felt my face flush. "Noelina, that's who!" I snapped. "You sick bastard—while you're getting your rocks off playing with this little invention, she's walking around thinking she's losing her mind 'cause she can feel somebody touching her!"

He blanched. "I—I never realized—"

"Shut up." I nodded toward the drying photos. "Dry 'em and pack 'em up, every last one. They're going with me."

"What about my check?" he complained. "I can't afford—"

"You asshole," I pushed my face close to his. "You can't afford not to. See what happens when you can't sign a paycheck, much less hold a camera. Am I making myself clear?" He nodded reluctantly. "And another thing. I don't care what else you do with this stuff or whose pictures you take, but don't ever let me catch you running shots of Noelina through this shit again. That means she never mentions to me again that she feels like somebody invisible's feeling her up, understand?" He nodded again.

"Good." I folded my arms and waited for him to get his shit together. Besides, I thought to myself sourly, the dirty fool didn't even have a good enough hand to make her happy. I blinked and gave myself a mental slap for even thinking such a thing.

But I was on the road to doom already, and God help me, even I knew it.

I was doing okay, really. The first couple of nights were the hardest, taking the prints out of the envelope and spreading them on my kitchen table, seeing these perfect little versions of an unclad Noelina squirming in every imaginable position, just begging to be stroked. But I made it—hell, a lifetime of not knowing what you're missing helps you grit your teeth when you need to. So I looked at the photos for awhile, then I put them away. To keep things difficult, I stuffed them back in the envelope and

put that at the bottom of a suitcase beneath all kinds of junk, then I put *that* on the highest shelf in the back closet, figuring the harder it was to get 'em out, the more I'd shrug it off as too much trouble. Like I said, I was doing okay.

Until we all went back to the studio to start a new film after a three-week hiatus and I had my first conversation with Noelina since before that scene with Matthews.

"What's the matter?" I asked worriedly as I offered her the traditional heavily creamed and sugared java during a ten-minute break. "You're looking a little pale. Are you getting enough sleep—hey, you ain't dipping into blow, are you? You know what Butch'll say—"

"I'm horny, okay?" Noelina snapped. "Does that satisfy your Little Nosiness?"

I blushed, then cursed myself for being such a wuss. "Sorry," I muttered.

She stared into her cup, the steam curling around her cheeks and lashes like mist from a hot Turkish bath. "No," she said after a moment. "I'm sorry. There's no call for me to jump you." She hesitated, then glanced around to make sure no one else could hear. "It's just that... well, remember—you know, that thing I told you about. That... touching?" I nodded mutely. "It's gone, is all. And I guess for all its weirdness, I miss it." She laughed suddenly, a little shrilly, like she was balancing on some fine, invisible line. "You'd think I get pawed over enough, wouldn't you? I mean, there's always a studley waiting and willing." Her eyelids lowered slightly, making her expression almost demure. "There was just something so... wondrous about it, like whoever was doing it was just fascinated by my body, or like they were doing something they'd never done before." She laughed again, this time self-consciously. "Yeah, I'm making sense all right." She looked up and grinned, the practiced movie queen mask sliding in quick and strong, wiping away all the wistfulness as she patted my arm. "Never mind, Ernie. You're a sport, you know?

Always listening and never complaining. The world could use a million more like you."

Noelina drained her cup and hurried away to where our camera/lighting director, some dipshit fresh out of film school who didn't know his dick from the cord coming out of the spotlight, stood and hollered for everybody to take their places. I fumbled around for a minute, trying unsuccessfully to clear my thoughts of the image of that hidden suitcase and Noelina's sweet, sweet words.

Life is a tough bitch, all right, full of contradictory situations like being a sport and trying to please the woman you loved, sometimes without her knowing it. Black and white, right and wrong—it doesn't always apply so easily. And that bit about the world needing a million more like me—hell, I wasn't even going to... *touch* that.

Matthews was a no-talent, greasy son-of-a-bitch, but he had something I wanted and I could give him something he needed. After two months I had to admit—though I couldn't for a second let Matthews suspect—that he had the upper hand. Sure, no one would believe his little fucked up pictures, and in this piranha business some director would cut the fool's throat for the formula if Matthews ever blabbed about it. So I just made sure he got his shoots as often as possible, picked up as much of the man's expenses as I could get away with, and hoped to hell he never realized how I'd fall apart without those pictures that he kept supplying.

And Noelina... well, she's a good woman. Oh, I know what people think about porn actresses. The truth is, there's not much difference between a pornography queen and a hooker when it comes to sex; both do what's necessary to make a living, and after awhile they all get kind of dead in the sensation department. Noelina's a beauty and not at all ignorant; this busty, smooth-skinned babe's creeping up on thirty and knows Butch is always testing the younger girls for a new headline queen. Noelina

doesn't do drugs or work the corners and she doesn't want to; she puts her money away as best she can, fucks the guy she's working with on the current movie, and that's about it. Beyond that, she doesn't date. Except...

She knows, I'd swear she does. All this time of being her confidant, it suddenly occurred to me that the last couple of months the woman's literally been spoon-feeding me a daily list of her sexual desires. And me, of course, dumb old Ernie behind his coke-bottle lenses—a cliché, I know, but the truth is a motherfucker some-times—and gangly, goofy-looking body with the perpetu-ally embarrassed face, I ate it up, grabbing my envelope from Matthews every night and running dutifully back to my apartment and... well, you can guess the rest.

The photos, I learned immediately, don't last. One stroke of a finger along the curve of a thigh, a gentle caress down the line of a misty-looking back or an exposed breast, and the holographic image melts away, merges back into the flat black and white it was always meant to be. But I learned, oh yeah, little techniques that made Noelina's image shudder with pleasure and strain to meet my curious fingertips. I even discovered that the longer I didn't lift my finger from her figure, the longer the image lasted; Matthews keeps shooting his porno shots in be-tween the other jobs I make sure he gets and I've accumu-lated quite a stash of photos—probably four or five hundred—that I've stored for future... use.

But even that doesn't matter anymore. Like I said, Noelina is a good woman, but she's lonely and untrusting, too. All those California-looking studs slavering around her constantly, and I still saw her talking to Matthews twice today, *twice*. Oh, I'm not worried about him, not at all. I just wonder what they're talking about, because sometimes I catch her looking at me and smiling, one of those little I-know-something grins. And Matthews, of course, that asshole's always been the lousiest of actors, all the way back to the first night I saw the holo photos in his

darkroom. Now *he's* grinning at me, too, the snake-eyed bastard. It ought to make me angry, the two of them, talking about me and smiling and shit. Then again....

I smelled her perfume—*Tabu*—before I felt her arm slip around my waist. When I turned her lips were only an inch away from mine and my mouth opened in shock. Certain parts of me that had been pretty good at staying dormant awoke with a vengeance as Noelina pressed the length of her body playfully against my chest and hips and hugged me hard; I could feel the silky heat of her breasts and her nipples all the way through my cheap shirt. Up this close, her eyes were very, very blue and filled with mischief. She slid her hands boldly down my hips and I gasped.

"Smile, Ernie," she said brightly. "Look—

"Matthews is going to take our picture."

Star Quality
Melanie Fletcher

I remember...

David stirred in the damp sheets, moaning. He was dreaming again.

It fooled him by starting out with Lara Roget, in a scene from their latest movie. Smooth, blond Lara with her lazy smile and sensual eyes, and was it really surprising when the script went past an R rating into censored territory? His fingers slipping underneath the velvet strap of her monogown, exploring the feel of silky skin, the subtle texture of a nipple. And then—

...blue skies...

The abrupt shift in scene. An image of textbooks on a battered desk. Grassy lawn, with blue sky above it. It had the taste of old iron, dread and anticipation sliding him out of sleep into polished fear.

...and the pain...

David jerked awake, gasping. The doctors called it sensory bleedover—uncontrolled feedback from the subconscious. Lara called them "morning's little horrors." Except that it wasn't morning, and the dreams were getting worse.

He lay back down, staring at the ceiling. The clockface above his bed blinked the time—7:30 PM. He'd almost overslept. It was time to get up, get ready for the party.

Fuck it. I don't want to go.

Fat chance. He could hear Maximillian's voice now—it won't do to keep the head of a major Hollywood studio waiting, David. As one of the acting elite of the 20's, he was under formal contract with Maximillian Hiller, the

agent of the decade. And a favorite subject of
Maximillian's (never Max—he hated diminutives) was
how members of the Hiller Group worked with the studi-
os, not against them.

Even with its director's quasi-feudal attitude, everyone
wanted to belong to the Hiller Group. The masses that
streamed into Hollywood would be sifted regularly, fine
psychological mesh screening the influx for talent, and
only the best, the hungriest, would be admitted to the fold.
That was one of Maximillian's proudest claims—all of his
clients were standouts in one way or another. Professional,
other agents said with envy. Maximillian never had to cov-
er up embarrassing pasts, arrange special hospital stays,
pay off local law enforcement. The Hiller Group were ac-
tors first and foremost, dedicated to their craft.

And part of that craft was to project an image, David
thought sourly. He rolled out of bed, heading for a shower
and the transformation that turned him from Joe Average
into David Masterson, Superstar.

Get ready, boy. It's showtime.

He arrived at the party just late enough to make an en-
trance. The eyes of the crowd—all people involved with
the Business—crawled over his skin agreeably, feather-
light massage on the ego. Something clicked inside his
head and he went into automatic pilot: nod here, kiss a
cheek there, get into the groove of things. *Project.* He saw
Maximillian with Lara and waved before the pair were
sucked into conversation with a leather-skinned mogul's
wife. When a director intercepted him with the inevitable
film offer, David managed to catch the agent's eye.

Briefly, the actor mused that Maximillian looked like
the ideal parent—six feet tall, a strong, kindly face, dark
hair edged with gray at the temples. The only thing that
spoiled the image was his eyes, an oddly flat shade of blue.
"David, my boy, good to see you," the agent said, cutting
into the conversation. "Enjoying yourself?"

"Of course," David replied pleasantly. "Jorge and I were discussing his next picture."

"Which David would be perfect for," Jorge added. He withered slightly under Maximillian's sudden attention. "The part was practically written for him, but he keeps dodging me—"

"Which he is supposed to do," Maximillian said smoothly. There was a new undertone to his words now, a polite aural ice. "All business deals are done through me, as I'm sure you know."

Jorge immediately became apologetic. "I'm aware of that," he said quickly. "I simply wanted to run the idea past David—"

"Which you've done. My boy, why don't you escort Lara around, while Jorge and I discuss his idea." Maximillian handed the actress to David before guiding the captive director father into the crowd.

Lara glanced after them, the demure expression melting into a smile. "This is the third time he's handed me off while he sets up a deal," she said sweetly. "I'm starting to wonder if I should ask for a cut."

David shook his head. "I don't think you'll get it. Maximillian doesn't appreciate it when people try to move in on his territory."

Lara chuckled. "I like it that way. It makes me feel more secure." She had a voice that had been described variously as soft, lilting, honeyed. Tonight, he thought, it was elegantly sweet; champagne and strawberries. "By the way, he has some work for us afterwards."

David nodded, understanding. The host, and probably the hostess. It was part of the job when you worked with the Hiller Group. The dream floated into consciousness again, overlaying the party—*I remember...* He twitched.

"What's the matter?" Lara asked. She looked up into his face, smile turning down at the corners. "You look like you've seen a ghost."

"It's nothing." He shrugged the dream off, back into his

subconscious. "You want a drink?"

"If you insist. Then we'll entertain the peons."

Two hours later, he took a break from the mingling. Drift from one group to another, be witty, amusing—it got tiring after a while. Lara was still downstairs chatting with people in the vast ballroom, and David wanted a chance to be alone with the night sky, polluted as it was. He leaned out on a second-floor balcony, tracking faint traces of starlight through the smog. And remembered:

I remember...

Another time, another place. Farther east, where people only watched the stars on TV, never thinking to become one of them. Maximillian had come to the campus right after graduation, where he'd met Ed McCarthy for the first time.

David felt like a ghost, watching Maximillian and the boy walking on the campus's quadrangle. The sky had been blue, very clear, and the sun had been warm on their shoulders as Maximillian explained how the boy could make a great deal of money in the entertainment industry.

Ed insisted that he was a biotech major, not an actor—he'd only done the commercial as a favor for his girlfriend. Maximillian demurred. Acting talent wasn't necessary, he'd said, not with the technological options at his command.

"You look lonely."

"I'm fine." Not moving, David tried on a small grin that didn't seem to fit. "Really."

He glanced sideways. Lara's profile was framed, outlined by the lights of downtown L.A. Classically beautiful. He tried to come up with the right answer, something that would describe the dreams he'd been having lately. Nothing seemed right. They stood there in companionable silence, the cool night breeze ruffling through their hair, before he said, "Do you ever remember what it was like? Before?"

Lara sighed. "I don't think about it," she said. "You shouldn't, either. It only confuses you."

"I know, but sometimes I can't help it. It's like I'm being invaded by memories."

She shook her head, moving away from him. She didn't want to talk about it, he knew. Lara was the ideal actress—calm, competent, perfectly adjusted to the change in her life. She had a magic that critics kept comparing to the screen greats—Gish, Hepburn, Streep. Great implants. Lara was never confused. "Maybe you should go see Dr. Berringer," she suggested, brusque. "Have him take a look at you. You might need an adjustment."

Unconsciously, David reached up and touched the skin underneath his right ear, massaging it with two fingers. That was where they'd gone in, with the surgical probes. "Maybe," he agreed.

A small surgical procedure, the newest form of wetware, and Ed would have the skills of the greatest thespians at his fingertips, Maximillian had said. The silicarbon circuits would interface directly with his brain, a biocompatible network riding the limbic ring. All he would have to do is memorize the lines, and the network would generate controlled emotional states to flesh out the character. For as long as he wanted, Ed would become the character.

It's an artificial persona, Ed replied. He'd heard about the procedure from professors, horrified at first, then fascinated. It wouldn't be me, just some software riding around in my head. Making me do things.

You make it sound so nefarious, Maximillian answered, smiling. Like it's a form of mind control.

Well, isn't it?

And this time, Maximillian did laugh, the father figure amused by a frightened child. Nothing of the sort, he said. You would have control over your every thought, your every mood. Your implant would simply remove inhibitions, allowing you access to a greater range of emotions, the skills you would need to

be a great actor. Think of it as a built-in acting coach.

"Anyway, I came out here to find you," Lara continued. "Maximillian's waiting for us upstairs."

"All right." David turned, willing the vagueness to be gone. He took control again, the smooth persona clicking into reality.

He dug his toes into the satin, thrusting harder. The woman beneath him moaned, winding slippery legs around his hips, whispering obscenities under her breath to urge him on. They'd been fucking for the better part of an hour, now, beginning with an almost Victorian scene of punishment and domination. No canes or belts this time. She only used words, but words were enough with her. Across the hall, he thought hazily, Lara was probably doing the same thing with the studio head, unless the man got into something truly kinky. Not impossible, but Lara knew how to handle that.

He pumped again, and again, until it was finished. Naturally, he made sure the woman came first—he could even hold back until she had two orgasms, sometimes even three. After love (because with him, it was love of a sort—wasn't that programmed into the implants?), he slid off to the side, holding her. The apres-sex comedown that women needed, he told himself. If you were going to do a job, do it right.

Her breathing quieted, finally slowing to sleep's pace. In the still room, he could feel other thoughts sliding up to him, demanding notice. Maximillian had said this would happen, even gave tips on how to avoid the bleedover. But tonight, David was too tired to fight. He let the memories come, shivering under their weight:

Why me, Ed asked.
Because you're the American ideal, Maximillian had said. They want your type, your voice. They'll love you. Maximillian

smiled, the cool charm turned up a notch. *And because it would make us both a great deal of money*, he added gently.

Ed flushed. Scholarships for biotech students were difficult to get, and he had been living on loans and side jobs. And with graduation, the loans would start coming due.

Five years with the Hiller Group and you would have the money for your bills, for a graduate degree, whatever you want, Maximillian said. *Five years with us, and you will have financial freedom for the rest of your life.*

In exchange for five years of slavery, Ed said, horribly surprised at a sudden, tiny desire to believe Maximillian. *An artificial persona was interesting when you were sitting around with friends in a safe dorm room, your mind still your own. The thought of actually carrying something like that in your head—*

I wouldn't call it slavery, Maximillian replied. *It's simply acting, taken to the ultimate degree.*

The woman eased into sleep. Only then did he slip out of bed, gathering his clothes and looking for a bathroom where he could shower. Luckily, the bedrooms were connected with a palatial bath. Soundproof door, he noted, closing it behind him. Good.

Lara was already there, washing herself at the bidet. She turned, looking over her shoulder, and gave him a cheerful smile. "How was it?"

"Not bad." David went through his clothes, hanging them on a towel rack. "Better than last time. Yours?"

Lara shrugged. "About the same. He likes to be on bottom."

David grunted understanding, stepped into the shower to wash off the woman's sweat. After a minute, Lara slipped in. "You mind?"

"No." He handed her the soap, and received a sudsy washcloth as a prize. Like cats on good terms, they washed each other. Asexual, friendly.

He was incapable of feeling any real attraction for Lara, wet and slick as she was. He was sure she felt the same

way—Maximilian had suggested that a romance between them wouldn't be in their best interest. He reached down to turn off the water, when a shadow appeared through the steam, watching them.

"Lovely," the studio head whispered above the water's hiss. "Lovely, children."

David felt Lara freeze, next to him. Waiting for the next suggestion, he thought disjointedly. Sure, we do requests.

"I'd like to see a love scene." The man leaned up against the sink, his eyes slipping over them through the moisture. "Now."

Compliantly, David straightened up. His indifference melted, changed to desire. His need was reflected in her eyes, blue and eager, as she rubbed up against him, the water from the shower no longer her only wet. He grabbed her roughly, the way the studio head wanted him to hold her, the water beading on their skin.

It had been the money that finally convinced him. A guaranteed $100,000 the first year; after that, the sky was the limit. A million and up wasn't impossible, they said.

What if nobody wanted to hire me, he had asked. The administrative section of the Hiller Group just laughed. Maximillian hasn't picked a loser yet, they told him. Don't worry. You'll be fine.

And he had. After the surgery, renamed David Masterson, he had co-starred in a fluff sitcom. Not surprisingly, the public loved him. After that, it was a string of steadily bigger movies, until he was signed as the star for his current movie, American Players. Women walked up to him everywhere, offering him their bodies, anything he desired. Men wanted to be like him. He was successful, a star, just as Maximillian planned.

And his memories of life as Ed McCarthy were dimming.

The sun was a faint shimmer over the Hills when he finally got home. Good party, he thought, throwing his jacket over the couch. Another one for the record books.

The events of the night, after the party—well, they didn't involve him, not directly. The sex had started after his first movie, with the producer and his wife. David remembered it in a clinical way; the quiet summons from Maximillian, being delivered to the hotel by limo. Wrapped up like a birthday present, he thought. It had been his first experience with a threesome, the feel of male skin next to his own. The producer's warm mouth closing over his cock, sucking it into hard life, and the taste of come later. Maybe that was when the dreams began to bleed over into his conscious mind; the ghost of Ed McCarthy screaming, he thought morbidly.

He had asked Maximillian about the sex once. These people were important in the Business, the agent had explained, and wanted intercourse with the godhead of entertainment. Contact with beautiful bodies, nothing more. And it was part of their job to supply that contact to the right people, he'd added. Every member of the Hiller Group did it. Nothing new—actors and actresses had been doing it for years. The implants was an improvement on the situation, a way to protect themselves emotionally. Let the implants carry you through, Maximillian had suggested before taking him up to that first hotel room. They'll know what to do.

Still musing, he poured himself a glass of orange juice. Standard morning ritual—orange juice, vitamin, a light breakfast. More suggestions from Maximillian. Thank God we're not shooting until noon, he thought, shrugging off the rest of his clothes, standing in his briefs in the middle of the living room. At least I can get some sleep.

He'd wanted to talk to Lara afterwards, but she had gone straight home. Instead, Maximillian had been waiting downstairs for him.

Lara told me you've been having some problems, he said, slipping into the father-confessor role. Like to talk about it?

And for the first time since David started acting, he didn't.

He didn't want to talk to Maximillian Hiller, father surrogate, chaperone, super agent. He wanted to work the memories out on his own. But Maximillian wouldn't hear of it.

I told you that might happen, he'd said easily, on the way home. Your body's immunological system is simply reacting to the implant. We'll have Dr. Berringer look at it tomorrow.

I don't want him to, David replied.

But Maximillian insisted. It'll only confuse you if you allow this to continue, David, he said.

My name is Ed, he said irrationally.

Maximillian was silent for a moment. In this place and time, your name is David. In two years, when your contract is up, you may decide to go back to that name. The agent smiled, and David felt chilled by that smile. Or you may prefer the one you have now.

No, I don't think so. But the words brought a strange, deep confusion. His life seemed to be a series of facets, beads strung on a chain. Somewhere, that chain had changed, forced into a new shape that was called David Masterson. Did that make him real? And what did that make Ed McCarthy? Unreal?

He could imagine the resurrection. The chain would snap, oh yes.

I can make the appointment for you this afternoon, Maximillian had said. Just a suggestion, of course.

Dully, he nodded. Make the appointment.

The implants were such a little thing, they had said, right after the operation. Just to carry you along. And they'd led him into a new life, something that Ed McCarthy had never imagined.

And the strangers? Midnight blending of flesh. It was another part of the life. Nothing personal, he could hear Maximillian say—it was only the body.

Changing his mind, David carried the orange juice out to the terrace, the cool morning air marbling his skin. He looked over the sleeping city and imagined them out there—the audience that wanted him to be what he was

now, not the repository of someone they didn't know.

Suddenly, he felt lonely, wishing for the memory of blue sky again. Wanting a past he knew was his own. Knowing, somehow, that it would never be there.

I Think I Scan
Jarrett Trane

God knows I could've used a Proz-patch just then to re-
lax a bit, sitting there on the couch in the drafty, open hall-
way that led onto the back corner of the set. Hell, even a
smoke would've been nice, but I didn't have any breath
mints, and the famous and reputedly mercurial Helena
likely was averse to kissing a co-star with smoker's breath.
Wasn't any point in ticking anyone off. It wasn't my style.

So, I sat there on the patched-up, rust-colored leather
couch with my hands sunk in the pockets of my favorite
old leather jacket, watching crew members drift by toting
equipment and otherwise looking busy. One wrinkled old
bulldog of a woman wheeled a small chrome cart of bed-
sheets by me and stopped under the harsh fluorescent
light in the corridor's low ceiling. She held each sheet up to
the light, then scowled at each in turn. No one paid me any
attention except for a cute young woman with shoulder-
length sandy-colored hair and oversized glasses—she
glanced at me nervously as she rushed by with a stack of
paper as though I might be another potential source of
stress.

A shaky-looking metal arm protruded from the wall
next to me with an old MPEG reader on it, but the outdat-
ed disks in its bin held little promise. Half out of its mylar
case was a sample demo of juvenile safari games that had
long since been surpassed in speed and resolution—one
didn't even offer changing POV. *Sex Entrepreneur*'s issue

on rising young scanhost stars—their pouting faces float-
ing in triD over the box lid—almost made me laugh. Two
of these stars-to-be never made more than one or two other
fuck scans, and I understood that the rest were either dead
or in 'tronic or drug rehab, except for "Candy Crawford",
who it turns out never existed at all but simply was a clev-
er construct modeled after a turn-of-the-century fashion
model. The copy of *PDA Hygiene and New Virus Detection
2023* held about as much interest for me as a shorted neu-
ral chip.

 The bulldog finally tossed her stack of linens on the
edge of the flimsy cart and the whole cart spilled its con-
tents onto the dusty floor. The clang echoed through the
large, barnlike studio. She spat out an epithet that would
make a Lunar Marine blush.
 I yanked my hands from my pockets and started to rise
out of the sagging couch to help. Her head spun toward
me and she glared in challenge. "Leave it!" she barked,
then stuck her toe under the strewn sheets and lifted them
onto the cart's lowest shelf, wedging them in with a grunt-
ed kick. I could see a wide streak of dirt along the edge of
several of the sheets. Madame Bulldog caught my eye as if
daring me to utter any protest. Out of habit, I shrugged
good-naturedly and favored her with my second-best win-
ning smile. Her glare morphed into an eye-rolling grimace
and shake of her head; apparently my charm was about
twenty years late to meet her tastes. She kicked the back
wheels of the cart into line and clattered on down the hall,
ignoring the tails of the three sheets that dragged along the
floor behind her.
 I leaned back on the couch, careful to avoid smashing
the back of my carefully coiffed, wavy brown locks against
the stained yellow wall behind me. I tried not to look im-
patient or tap the molar crown that activated the bone in-
duction clock announcement transmitted from behind my
left ear. Since Seiko had developed the dentalclocks, the

term "tongue in cheek" had taken on a new meaning associated with dismissive impatience. Like I said, impatience was not my style. I learned that from Mama—how to sit without looking bored—while we waited in the car for one of her co-workers to finish her rendezvous and come out to the car re-adjusting her clothes. Mama'd let me play with my old Gamedude, the broken earpiece taped together so that the lenses wouldn't slide off my face. Mama never would turn on the radio or netvid, but would sit with her stubby hands resting on the steering wheel, her gaze fixed on whatever was parked in front of us.

The door at the far end of the hallway creaked noisily open, and a man's long, slender face poked out and stared at me. I gave a bright-eyed smile, as though just roused from a pleasant catnap. The man looked at me blankly, then the corner of his mouth jerked in an acknowledging tic—nothing more. Clearly, my humor wasn't winning them over here. His head disappeared through the door.

Just as I straightened in my seat, the door lurched open in two movements. A short figure in a filmy black jumpsuit minced out the door in three-inch heels. Although her dark hair was short, it obscured her face, which was turned back toward the heavy door. "So what the good goddam *else* is new? The sun rising in the East and the Dodgers not being able to play infield? *That* surprises me. 'Lena showing up late? That does not surprise me." Her voice was like a badly tuned flute—high pitched but full of unexpected intonations. She sounded like maybe she originally was a foreigner with a good ear for pronunciation but not for pitch. Her head whipped around and two large, heavily made-up eyes flared at the sight of me.

"For the love of pre-pubescents, what the hell are you?" I realized her dark hair was actually sort of navy, with iridescent highlights flickering from the reflected glow of the harsh fluorescent lights. "Are you the c'rupted new meat?"

I popped up in what I hoped appeared to be a casual, languorous fashion and offered up my topmost winning

smile. "Not c'rupted at all, ma'am. Checksum'd out at a
full eight inches, and I'm raring to go. Buddy Bonner here,
your most humble slave." Maybe I was pouring it on a bit
thick, but one didn't want to take chances with the top
scan director in the nation. Her shoulders sagged in overly
dramatic defeat. She gaped at me for a full beat, then
twirled toward the heavy metal door, hands on hips.
"Dejah-Juan!" she shrieked. The slim-faced man slipped
through the doorway, clearly straining to push it open.
The remainder of his body also was skinny, almost cadav-
erously so. "D.J. Did my career die someplace and no one
told me? Is this some macabre hint to let me know that I
was washed up—giving me this piece of *merde de la boeuf*
as my male lead?" I tried to laugh through the mock insult,
until I realized that she was not smiling.

The emaciated DJ scampered forward. "No mistake,
Ms. Drinet. Bonner is one of the hottest hosts in the region-
al scans. You wanted someone new..." His nasal tone al-
most invited you to try your luck with a hedge trimmer on
those adenoids.

"What region? Shallow Genepool, West Virginia?" My
smile dropped to Level 3, effective only on grandmothers
and girls with really bad acne. "Where ARE you from,
Slick?" Her voice said she really didn't care, but to ignore
her could only make her bitchy temperament only meaner.

"Well, I was born in Tulsa, but I've lived in Atlanta for
nineteen years and I also summered in Massa..."

"Oh, great—Tulsa. I've got megabucks and a helluva
reputation riding on this loop and they send me my meat
from Oklahoma. I bet when I get home tonight I've got a
new cook from England and a Canadian car." Her voice
rose to an almost hysterical pitch, which seemed a bit over-
ly dramatic. I didn't think she wanted me to point out
again that I really hadn't lived much in Oklahoma. DJ
waved his hand helplessly, as though my employment had
been mandated by omnipotent gods over whom he held
no sovereignty.

"Okay, Okie, lose the dead animal skin." My wan, un-comprehending smile irritated her more. "Take off the leather jacket." She sounded the words out as though I were hard of hearing. I quickly doffed the coat, and stood there in my fleece pullover and tight chinos. Drinet grunt-ed approvingly. "Good shoulders and pecs—that'll save us a bit on enhancement costs." She reached behind my neck, her long-nailed fingers groping for the socket and trans-mitter chip. Her breath reminded me of cloves and old vegetables. "Jesus, where'd you get this socket installed, K-walmart?" She flicked one of her glowing dangling ear-rings with her middle finger and craned her lips toward it. "Hiro, are you getting a reading from the transmitter?"

A voice responded in mid-air, seemingly about three feet from us. "It's acceptable, Lady D. Not great, but it'll do. Unless you wanna invest in a new socket for the guy."

"Hilarious, Hiro. Let's check levels." She turned back to me. "Okay, Tex"—I swallowed the protest about my home state—"give me a memory of something pleasant. How 'bout your first blow job?" I concentrated on that evening with Suzanna behind the VR arcade.

The voice loomed again. "Minimal, Lady D. It'll do, but he can't drop off much."

Drinet's voice dripped, "Whattsa matter, Tex—not much of a memory? Did she even manage to get it out of your pants before you went off?" My cheeks flushed.

"Okay, let's try some anger now." I tried to recall some slight by a bully at school.

"No go—it barely registers. Has the socket slipped some?" the voice intoned.

"Nah, Tex is just too thick to get mad at anyone." Her voice lowered. "C'mon, guy, give me a good blast of hate. Maybe the first time one of your brothers cut you out of your turn at fucking your sister."

I clenched my fist and drew my arm back, torn between swinging at her and telling her that I didn't have a sister. The voice cut me off.

"That's just above the line, Lady D, but don't have this fellow doing Hamlet going after Polonius, if you follow my drift."

Drinet snarled back at her earring, "Don't think this role requires it, Hiro. Although, I'm not sure he can even pull off a good housepainter."

I stared at her. Housepainter? We were going to do the hoary, old housepainter seduced by the housewife routine? She tilted her head to the side and stared back, her lips pursed.

"Ahhh, did Tex think he was playing Richard III today? I'm sorry, that's been cast." Her tone hardened. "This is your first time out of the chute, so you're lucky that you're anything more than the third cuntlapper in a gang bang. Now let's get you prepped for all three of your lines." Her chin rose and she clattered out onto the sparse set, which consisted of two-and-a-half walls worth of bedroom and an institutional-looking bed and dresser. The bulldog was sloppily making the bed; I could see the dirt on one corner of the sheet.

"Where's the script bitch? Charel, where are you, you stupid cunt?" she shouted.

The sandy-haired young woman I'd seen earlier rushed out with her arms still full of folders, the loose legs of her green-gold pantsuit flapping behind her. Drinet waited for her with crossed-arms, her fingers twisting. Drinet resumed the lecturing-to-an-idiot-child mode. "Charel, take the Okie meat here into a dressing room—not Helena's—and work with him on his lines and blocking. And don't take it too fast, 'cuz I think he's running a bit short of free-mem, okay?" Charel nodded and pushed her slipping glasses up her nose. A slight, unnatural bend at the bridge of her otherwise pert nose impeded the task.

Before she could move, the door at the end of the hallway opened, and a stocky, greasy-haired man, filled with self-importance and crammed into a too-tight suit, pushed himself through. He stopped and held the door open, and

a woman with lank, bleach-blonde hair clad in a baggy mirrorsuit clomped through. She was licking her fingers, having apparently just finished a snack. Drinet rushed over, almost falling off her heels in the effort.

"Helena, dear," she gushed, "so good to have you here today. We've got a handsome young man here for you to fuck, and we'll get you through it all as quickly as possible."

The newcomer looked up. I was stunned. This was the world-renowned Helena, object of millions of wet dreams? I realized that the scans were doctored a bit and the viewer usually didn't get a really good look at his scanhost's partner in the middle of a sex act, but she was hardly what I expected. No wonder she had a reputation as a bit of recluse! The publicists claimed that her private lifestyle made it easier for her the public to accept her in each new persona she adopted in her scans. To be sure, she was famous for really putting her viewers in the emotions of her role, as well as creating a major trouserlump for the men chipped into her host partners. I remembered guys staying out of work for days after her "Milkmaid" scan was released, just playing the chip over and over.

Now, though, her appearance in person suggested that the reclusiveness bit was just a way for her fans to be sheltered from the real Helena. Certainly her reputation for insisting upon as little enhancement as possible of her partner's scans of her was total horseshit. Her face had the same shape I recalled from the scans, but the eyes were bleary-eyed and somewhat vacant. Her skin was sallow and suffering from a recently acquired rash, no doubt brought on by overuse of Proz-patches or ephicaine. Remnants of her latest meal still clung to the corners of her mouth. I could not make out much of her figure underneath the shimmering, hypnotic swirling of the mirrorsuit, but it seemed that her hips were a bit more generous than I remembered.

Drinet stepped back and turned as though to bring

Helena over to me, but the superstar merely glanced at me, flipped her hand in bored acquiescence, and strolled over toward the dressing rooms in the middle of the hallway. Drinet bustled behind her, synchophanting and gesticulating wildly. As Helena entered the largest, end dressing room, Drinet stopped and shed her smile. She motioned the skinny DJ into the room while waving her arms around her head to indicate that a major makeover might be required.

Drinet then returned to me. Almost as though confiding in me, she leaned closer. "Not quite what you expected, huh? With the money she makes, it's hard to keep her slim and clean. As soon as we dry her offa one drug, some bathtub genius invents a new one and slips it to her. Fortunately we've got a budget that allows for lots of enhancements. All the same, be sure that you try not to look too much at her face. We'll try to patch in loops from her partners in some of her old scans that will match your scan patterns closely enough. Also, make believe that her waist is still a skinny little thing. Think you can do that for me, Tex?" I grimaced.

"Look, sport," she went on. "No matter what she looks like, Helena can emote like no one ever. The ladies love her chips. She comes buckets; they come buckets. It's that simple. This is not work that just anyone can pull off. Lots of people can *look* like they're having great sex, but when you put a chip in their heads, the viewer knows when they put the cartridge in their own socket that the host is just faking it all along and really just thinking of the mortgage or worried about the mole on her ass showing up. Helena can come across on the chip as one-hundred percent into it— into her character, and into the sex. So, this means that she gets the work even if she's not in top form. You, on the other hand, just gotta do your job, pick up your ten grand, and go tell your grandkids that you got to lay the great lady of American fuck scans."

"Well, yeah but...." I stopped. "Wait. *Ten* grand? I was

told this was for twenty-five thousand! Hell, I made eight grand for my last scan in Jacksonville."

"Sorry, Tex. No one has authority to offer any more than ten grand but me. If you were told different, you take it up with them. Just chock it up as your entrance fee to the big time and hope that someone else likes your performance in this loop. You get a quarter percent net royalty, so if this one hits as big as the last, you might get another ten grand or so. But, I gotta tell ya, I don't think she's gonna be very focussed on this one, so the reviews might not bring in the big sales." She shrugged, but her malicious smile belied her expression of sympathy. "Now take your tight little ass off to learn your lines—hell, you'd better learn Helena's too, since she's not in any shape to remember anything but the name of her patch supplier—and be back out here in twenty minutes. Maybe we can get Helena presentable by then with a few low yield thermonukes."

"And Charel," she added, turning to the mousy script girl, "please do not fuck up his head with characterization and motivation and all that. He's just the meat, got that?"

Charel swallowed and nodded, and then she motioned me back down the hallway. I followed her slim figure, my emotions grinding. I took several shallow breaths, like Mama had taught me to do when you're upset by what someone in authority has done to you, and started to calm down. We went past Helena's dressing room, around some piled boxes of promotional flyers, and down a dank, dimly lit corridor to a door inscribed "Aux. Dressing Room." She motioned me in.

I flipped on the light and looked around. The room wasn't as bad as the rest of my experience suggested I'd discover. The room actually had a sink and make-up counter with full-length mirror, and a large, plush couch for guests. I sank into it.

Charel perched carefully on the arm on the far end of the couch and handed me a folder. I didn't open it, but lay my head back and closed my eyes. "Is Ms. Drinet always

so charming?"

The young woman stifled a chuckle. "Believe it or not, she's not much worse than most in the business, or so I've heard. She's the only director I've worked for since I've started back working."

"Yeah, but calling you cunt and bitch and all that. That's a bit much."

"It didn't sound like she was being very nice to you either, Mr. Bonner."

"It's Buddy, dear, just Buddy. Mr. Bonner is my father, wherever his miserable ass may be now. And, yeah, she was kinda rough, but that's alright. Abuse just rolls off my back like water off a duck. Geez, there I go again sounding like a hayseed right off his hovertractor. But when this gig is over, I can move on. Looks like you'll still be tied to the little tyrant."

"Yeah, more than I care to think about."

I opened my eyes. Charel's head was bowed. "Huh? I don't mean to pry, but..."

She looked up at me, her startlingly blue eyes were starting to brim with tears. "Look, Buddy. I'm here to get you set for your role. We should get to that. It's my problem, okay?"

I opened the folder and glanced at the one page script. "Let's see. I knock on the door—'I'm here to paint the house'. She says, 'I've got something else for you to cover.' She strips, I strip, I suck, she sucks, I'm on top, she is, we're up against the wall, back in the bed, we come. Okay, I'm ready. Now then, what's your problem with Drinet?"

Little alarm bells were going off in my head warning me not to get sucked into this lady's problems with the she-devil. All it could lead to was the she-devil heaving me off the picture. To be sure, my little brother would have approved of my interfering. Back in Oklahoma City, he heads some social service agency, pouring his life into making existence a little better for the poor and the drunks and the wirefried. I see him once a year or so, and he

always gives me the stock lecture about the miserable direction of my life, tending to dwell on the line of work I'd fallen into. The most recent one went something like this.

"Gee, Buddy," he'd said, "don't you care about anything, even yourself? I mean, you've never committed yourself to much of anything. You don't get mad at anyone, and all your girlfriends have left you within a year complaining that you didn't seem to give a damn whether they were with you or not. You don't give a second thought to letting someone drill a hole in your skull and doing these sleazy porno sex scans so that a bunch of perverts sitting at home can tune into your innermost thoughts and perceptions. Heck, you even use your real name, ruining your reputation for doing something important or useful later on."

"Hey, little bro," I responded. "I'm just doing what Mama told us. 'As long as you ain't hurtin' anybody, you just do what you have to do.' That got her through and put us through as much school as we wanted. She couldn't program a lick, but she kept her job for eighteen years at Microsoft. That's all I'm doing—doin' what I've gotta do."

My brother, being around those politicians, always had a smart answer. "Well, at least she cared for something— her sons. You don't even have that. And how good could that have been for her self-esteem, knowing that the only reason she kept her job was that all the women in her section knew that she was always willing to cover for them when they wanted to spend an evening with their boyfriends? Remember all those husbands who must have thought that Mama was a real fascinating person because their wives—who never even went to lunch with Mama— were supposedly going to museums or plays or triD's with her?" Needless to say, our arguments never moved either of us one lick, and we'd drifted even further apart as I continued my work on the scans.

Still, I'm not sure my brother would have thought that chatting up the script girl in a fuck scan was his brand of

social work. She just sat there on the edge of the couch, twisting the skin on the knuckle her hand, staring at the floor, debating with herself as to whether to open up to me.

"You see, Buddy, I'm just really in a bad spot. My husband left me and the baby last year—after he thoughtfully left me with a little gift." She touched the bump on the side of her nose, where it obviously had been broken. "Kevin then cleaned out the bank account, so I'm trying to go back to school so I can earn enough to get by. This job doesn't pay much of anything, but the hours are flexible enough that I can keep up with classes. What with day care, even video monitored care, I'm just not keeping up. Ms. Drinet says she can refer me out to act in some of the cheap shops where they can use me in some of the group scenes for the party chip market, but I just can't do that!" Her voice was almost a wail. Now it descended to a whisper. "But I don't think I have much choice."

"Can't they loan you some money...?"

She snorted, although on her it was almost engaging. "Are you kidding? Around here, they throw quarters around like pianos. Ms. Drinet says she'd loan me some money for a portfolio if I agreed to do the party scans—but I think that's because they'd give her a commission for finding me."

"Look, honey, if it's simply a matter of a few bucks, I've been working really steady and you look like the sort who's very responsible about paying a guy back. We could work something out."

Charel slid down onto the couch next to me and put a cool hand on my mouth. "No, I didn't bring you here to help me out." She kissed me on the cheek. As silly as it seems given what I was employed there to do, the peck actually sent a little charge down my spine. "I'll figure something out to get by, whatever it takes. You've got your job to do here, and it doesn't include me. Now, let's get you ready." She looked down at one of the folders remaining in her hand.

"Now wait a minute," I interjected. "Neither you or me have to put up with this kinda shit from them." The woman looked up, surprised. "They've been treating both of us like we're some kinda shit cleaners who they don't mind scraping out the sewer lines so long as we don't come in and sit on the furniture. They think they're hot stuff because of their international reputations, but in trying to cheat me outta fifteen grand, they're no better than a bunch of street corner bums. I'm gonna charge right out there and tell that bloated Helena that she's a pock-marked whore who turns my stomach and that I wouldn't take a piece of her sorry ass for four *hundred* thousand dollars."

Charel patted my knee. "Now, Buddy, you're not really going to do that. If you break your contract, they'll black-ball you from the business and sue your ass for the cost of bringing everyone here for the production."

I started to calm down. This little tirade was a bit beyond me anyway. "Well, maybe. But, I don't want any part of their damn housepainter story and their puny ten grand. If there's any way I can walk, I will."

"Buddy, I wouldn't think that ten grand is puny." Her voice was small.

I felt a bit ashamed. "Sorry, I guess you're right. But I'm serious about getting out. Maybe I could stub my toe so I couldn't perform or... I don't know. Jerk off on the floor and come out limp and just say I was having a bad day. They couldn't do anything if I did that, could they?"

Charel giggled. It was an enchanting giggle. "Noooooo, they couldn't really do anything about that—unless they came in and saw the evidence on the floor." I started giggling back. It would serve them right. I laughed louder, and Charel did too. I looked over, pleased that I'd cheered her up. Hell, I'd cheered us both up.

Suddenly, I found myself drawn into Charel's blue eyes. They were wondrous. Theirs was the blue of the first robin's egg you found in the nest of the first tree you climbed up all by yourself, of the first watercolor you did

in school, of the tux you wished you could afford for the prom. I grabbed her hands, long and slim, with nicely-manicured nails. She smiled fully now; we had crafted a bond somehow.

I impetuously leaned forward and kissed her. She squealed prettily. I thought maybe I'd overstepped my bounds, but then she kissed me back, her soft lips opening to me. Her fingers rose to cup my face as we turned toward one another on the couch. My hands grasped her slim waist and then glided up her back. As the kiss continued, she pressed herself against me, and I realized that her simple pantsuit hid very firm, high breasts. Blood rushed right to where you'd expect it would.

We giggled again as our lips played, prodded, wrestled. "Buddy?" she asked in a small girl's voice. Our foreheads rested against one another.

"Hmmmmm."

"You know what I'm thinking?"

"What?"

"I think I just figured out where you can hide the evidence?"

"Huh? What evid.... Ohhhhhhhh."

With astonishing ferocity, Charel wrenched my the tails of my shirt from my pants and yanked it over my head. I returned the favor, then unclasped the magtab on her simple white bra. It slid off, and I found myself looking at the tautest, sweetest set of breasts I'd enjoyed in any of my scans. My mouth captured one small, pale nipple and laved it to hardness.

Charel moaned and pressed my head into her chest. "Oh, god, Buddy. It's been so long since Kevin, and I need you."

She reached down between us and her fingers cupped the bulge the had risen to full rigidity at my crotch. "And thank the good lord that you need me too," she gasped. She permitted me to attend to the worship of her magnificent young tits for a moment longer, then pushed me back

onto the couch. As I sat panting, she pushed on my knees and stood, where she tucked her thumbs into the waistabs of her pants. They dropped to the floor.

With a crooked grin, I leaned forward. "Let me thank the lord too. In fact, I think I'll say grace." Sitting on the edge of the couch, I pressed my lips into her flat stomach just above the waistband of her white panties. I searched for and found her clean, womanly aroma as I nosed around the legband of the briefs. Her breath caught.

My hands cupped her tight asscheeks through the fabric of her panties and then dipped underneath to knead their wonderful softness. I dropped two fingers down to the strip of cloth covering her vulva and pulled it away from her curl-guarded cleft. My mouth slid down to allow my tongue to lap lightly along her outer labia. Charel's moans increased and her fingers clenched my hair, pulling me toward her heated loins. My tongue slid inside her mons, already swampy with wetness. Clearly, it had been some time since she'd had a man. While my lips alternatingly caressed and sucked at her hardening clit, my tonguetip continued its fervent, pulsating invasion into her sweet young pussy. I could have remained there forever.

Now Charel was panting, interspersed with a high-pitched keening. "Oh suck it, Buddy," she pleaded. "Suck my clit." I removed my tongue from her flowering, liquid tunnel and devoted my attention to the woman's fully engorged clit. My pursed lips tugged and played, while my tongue laved lightly over the node. As the pitch of her wails started to increase, I brought my thumbs up to caress each side of the fleshy hood that covered her little bud. Only seconds later, she emitted a choked gasp and clutched my head with superhuman strength, holding me still with her nails pressed into the base of my skull. Her legs vibrated, and then she announced her release with shrill screams. Her head was flung back and her lips pulled away from her teeth.

She jerked out her release for a good thirty seconds,

uttering endearments and joyful obscenities almost non-stop. Still, she somehow remained standing.

As she finished her climax, she began to sag forward on top of me, resting her cheek on the top of my head. "Oh, Buddy. That was incredible. Just incredible." I felt pretty good about the experience myself.

"But," Charel continued, pausing ominously. I looked up. She beamed down at my face, still wet with her juices. "Buddy, we haven't destroyed that evidence yet, have we?"

She pulled me to my feet and started wrestling with my belt and zipper. As she yanked my trousers and shorts together over my hips and down my thighs, I began to have second thoughts. Sure I was aroused, but throwing away ten G's on some principle just wasn't me. Even as my turgid cock bobbed into the harsh light of the dressing room, I began to compose a gentle way of suggesting that perhaps I should go through with the scan.

I looked down at her, and all such thoughts fled. This sweet woman-child—to be sure, a mother and former married woman, but somehow still an innocent—was looking up at me beseechingly. She dropped to her knees, still dressed only in her now-stretched bikini panties. Her gaze locked onto my cock, long and thick by just about anyone's standards, but she didn't speak at first. Her hand slowly rose to meet it, and her fingers encircled the shaft just behind the head. They slowly stroked me to further tumescence.

"Buddy," she whispered. Louder now, she added, looking up at me, "I know you're used to professionals and all, but, you see, you've brought me something. Like maybe I can break the cycle and make a difference in my life, and others' lives too. I want to give you something, even if I'm not very good at it."

With that, she let her face slowly drift forward until her slightly parted lips collided with the tip of my manhood. Her small pink tongue peeked between her lips, and

twirled over the head of my cock, smearing a dewy emission over the red helmet. Her left hand rested under my hanging sac, lovingly caressing the sensitive skin. Her mouth opened further, and her face darted forward. I was swallowed almost halfway into her wet, gentle maw. I groaned in pleasure, and she could not suppress a smile around my mouth-filling breadth. With the thumb and forefinger of one hand sweetly collaring my cock and the gentle fingers of the other teasing my balls, she began bobbing her head to and fro, the warmth of her lips never harsher than a feather's touch. I encouraged her with another, entirely genuine moan of ecstasy. Her eyes filled with glistening passion and never left my face.

With a lustful moan of her own, Charel threw her lovely face forward, taking me fully into her throat. She gagged, of course, and pulled back with a child-like cough. I was about to tell her that it wasn't necessary to try to please me that way, but her determined mien silenced me, and she again flung her mouth over my rod. I felt my tip enter her throat and pass into it. With an almost desperate, painful groan, she maintained the depth, and then converted her moan to one of triumph as she miraculously held me inside her mouth nearly to my full length. Finally, she allowed me to withdraw. She took me fully inside a half dozen more times, inflaming my loins and emotions with her devotion and instinctive skill.

Finally, she pulled her head back and looked up at me, panting. "Buddy," she pleaded, "I don't want to be selfish, but I really want to—have to—have it inside me."

I smiled—again, my topmost smile, if not one even better than my previous best—and pulled her to her feet by her hands. I shook my head in wonderment. As many times as I'd been, well, "serviced" seems an appropriate term for a professional's blow job, this was the first time that I'd felt truly transported by the passion and commitment of the woman performing the act. "I'd like nothing better," I said.

Charel paused to kiss me, her sleek body pressed against me, then sank back onto the couch. As she extended her long, slim legs up onto the sofa in front of her, I knelt to grasp the sides of her now stretched and soaked panties with the middle fingers of each hand. Her hips rose like a dolphin breaching to permit me to slip the garment over her hips and down her thighs.

Her legs remained coyly together. I chuckled at her modesty. Grasping her ankles, I threw her straight legs directly above her, then knelt on the couch. She felt my rock hard cock bob against her thigh, and her closed-eyed face rocked from side-to-side in anticipation. I grasped myself and prodded lightly at her portals, tracing the outline of her moistened lower lips and teasing at the very opening.

Charel's eyes sprung open. "Oh, Buddy. Please don't tease me like that." Her right hand darted down to rub my hip and thigh, and then, as though it was not her plan all along, brushed my hand away and claimed my rod for her own. She guided me to her entrance; no force in nature could have granted me the will to refrain from pushing forward.

As I entered her, Charel brought her knees apart and back toward her chest, giving me full access to her. She was snug as I began stroking into her delicious tightness, but soon flowered open to receive me fully. Charel's long fingers cupped my asscheeks and guided my tempo. As I settled into a pace that satisfied her, her hands slid back up between our glistening torsos and took my face into her hands. I opened my eyes to see her gaze lovingly into my own, and then she pulled my face down to join our lips in a passionate kiss—meeting, tickling, testing, and then flowing into a nibbling, tonguing, groaning duel. As the kiss continued, Charel's heels slid along my hips and ass, further guiding the angle of my cudgel's probe.

Sooner than I expected, I felt the pulsations of her thigh muscles that signaled her impending explosion. My surprise and delight was mingled with mild gratitude, as I

recognized that the desperate, unequivocal passion of the lovely young script girl had brought me to a fever pitch as well which I could not long sustain.

After a few more strokes, Charel's lips dropped away from mine, and her mouth opened in a silent wail. Her eyes stared blankly up at my face. Her thighs and knees tugged to and fro to force me into her deeper and faster. With sweating determination, I complied, and within a dozen penetrations she screamed and locked her ankles behind my waist.

Her unintelligible scream transformed into a shriek. "I'm coming, Buddy - come with me now!" I felt the pulsations of her exploding pussy caress my own sex, and I leapt into the chasm with her. My own explosions were enhanced, emboldened by Charel's on-going paroxysms of ecstasy and punctuated by her cries of lustful completion. I poured myself into her.

As the last spurt of my seed shot up into her, my beautiful partner again pulled my face to hers in a passionate kiss. She stared at me with newfound clarity, and vowed, "Oh, Buddy, I won't ever let this end—I love you and want to be with you always."

Her words were like rain to a man dying of thirst. Suddenly, I found myself uttering the words that I'd resisted offering any woman, no matter the provocation or incentive, ultimatums or pleas. I said quietly, "I love you too, my darling Charel." And, we kissed again as the final tremors squeezed out the last remnants of our passionate explosion.

My head was flooded with thoughts, dreams, wishes. Plan after plan rushed into my consciousness, as I envisioned fantasies where I could care for this extraordinary, abused woman and her child, where I make a new life where my self-esteem was not battered by compromises and debasement by others in control of my existence. I reveled in the realization that I could make this stand, this commitment, for love.

Charel's voice, soft but firm, cut through my reverie. "Buddy, darling, you're kinda crushing me." Apologetically, I withdrew from her and rose back on the couch to where I was kneeling between her extended calves. She gracefully pulled her legs back to her chest and then swung them around, bringing her to a sitting position.

I smiled in wonderment at her. Only a brief, tight-lipped smile was returned. "Uh, Buddy,there's something you should know. And, please, accept it as being for the best. And I really mean it when I say that you're a very good lover."

My smile dimmed in confusion; it was now back somewhere in the range of a third-level smile suitable for asking strangers for directions.

"Buddy, we really couldn't tell from the cheap quality of the scans you did how well your characterization would hold up in a real, major league scan, so, well..." Charel glanced down at the floor.

My head jerked to the side as the door burst open and the diminutive Drinet popped through. I leapt protectively in front of Charel, explaining, "Now Ms. Drinet, it was not Charel's fault, and I'm not going to go through with the scan and your goddamn..."

I stopped, unsure of exactly what I was going to say and perplexed by the broad smile on the dark-haired woman's face. Dejah-Juan trotted in. The old bulldog set assistant plodded in behind him carrying two bathrobes. She handed one to Charel and then pressed the other into my uncomprehending fingers. Balancing on his toes, the slightly-built Dejah-Juan reached up and plucked the scan transmitter chip out of the socket in the back of my skull.

Drinet patted me on the cheek. "Well, that's great, Mr. Bonner, but we're in fact all done here. Let me complete what Helena was starting to tell you." I gaped back, then whirled on the script girl. Charel was donning her robe, but stopped to tilt her head to one side. Dejah-Juan

reached up under the sandy-colored curls cascading down her neck and pulled out an identical chip!

My lovely young partner then pinched the bridge of her nose between thumb and forefinger, then pulled off the lump from her "broken" nose. She caught my stare and responded with a coy, guilty grin. "Yup, the famous Helena—it is I." Damned if she didn't actually curtsy! "Like I was saying," the putative script girl added, "we weren't sure if you could pull off the character, so we just ran it for real. Hope you don't feel foolish, Hon, but we got a much better reading off you this way."

Drinet nodded. "We got a great read. I think this will be very successful, a classic. The scanhost stud spurns the superstar and falls for the sweet, tormented young script girl, leading them both into a life of redemption and happiness. The fun part is, in post-production we replace every mention that you and 'Charel' made of Helena with the name 'Annerose,' that stupid bitch who thinks that she's the top boss sexscan queen. It's hot, it's romantic, and it sure as hell worked!"

Slowly, it all started to fall into place for me. I wasn't going to give either of the two women the satisfaction of asking them to diagram the whole setup—it now was pretty obvious that the only story to be scanned was between me and "Charel". There never was any "housepainter tale", and the dowdy "Helena" who'd crossed the room earlier was just a stand-in. All the abuse they had shoveled out was intended to get me so pissed off that I'd fall for the script girl's tale—and the script girl herself. I had fallen in as easy as a scared possum down a burrow hole.

As calmly as I could manage, I slipped into my robe.

The real Helena strode up and gave me a perfunctory buss on the cheek. "Hope it works out for, ya—Tex. Here, have a souvenir." She handed me the sweaty, wrinkled prosthesis that had been the bump on her nose, and giggled. She trudged off, with D.J. following her carefully clutching the transmitter. The bulldog brought up the rear

clutching "Charel's" discarded clothes.

I turned toward Drinet. She backed up a step, her eyes darting around the room in the realization that she was alone with a much larger man on whom she had just pulled a major mindfuck. She brazened it out. "Now, look at it this way, Bonner. You'll get the whole twenty-five grand that you were promised and, as hot as this tale is, probably end up with another thirty to forty in royalties. You're gonna be publicized as Helena's hot new stud, and oughta get some feature slots in really prime scans. Even if you never figure out how handle your emotions enough to fool the scans, you'll get a minimum of four or five jobs until folks figure out that somehow your acting in this scan was a fluke. I assure you that no one here will ever tell anyone that this scan was anything other than straight up. Hell, if you ever drop down to the regionals again, you'll be so famous as one of Helena's co-stars that you can work until your dick drops off. See, in a way we did you a great whopping favor by not telling you what was going on." She raised one thickly-penciled eyebrow.

I closed my eyes and let it all flow out of me in deep breaths—my original anger at Drinet for her taunting and insults, my disappointment and betrayal at the loss of my dream life with the fictitious Charel, and my outrage at the whole fucking lot of them for making me the butt of their scheme. I had to admit that, on a practical level, Drinet was right; I had a lot to look forward to coming out of this. With the experience of making three or four more top-level scans, I ought to be able to pull off a decent persona that could fool the scans and then viewers. Hell, after all, I'd been submerging my real feelings my entire goddamn life.

Maybe that was the damn problem. By stuffing my emotions in the back of a drawer like I'd always done, I didn't know what to do with them when I brought 'em out in the light. And, when I finally did so, bottom feeders like Drinet could mold my emotions this way and that, and I couldn't even detect that they were doing it, much less

keep ahead of their manipulations. In my passion for Charel, and then later my rage at Drinet and the whole fucking industry, I'd been like a ten year old given a rifle for his birthday—you wouldn't know where it was pointed or when it would go off.

I felt all of a sudden like I was at the crest of a hill where the air was thin. The tightness in my chest was palpable. From this hilltop, dozens of paths headed off in different directions. I could take any one, but most of them seemed to lead into the same kind of emotional bramblebush that I had thrashed my way out of, at least for the moment. I knew maybe one led to a real Charel, and maybe a place where I safely could let my feelings have free rein and get to know them—and myself—a bit better. Who knows, maybe a little self-knowledge would keep me out of the talons of Drinet and her ilk.

But then again, if I'd been an emotional fellow all along, I would never have been able to make my first scan, and sure as hell never would have survived to make it to this point in the first place. And maybe those bramblebushes along the paths were all that was keeping me from sliding further down the hill.

My eyes opened; Drinet's nervous smile was still in front of me. I let her wait a few seconds, and then smiled back. "Sure, Lady D. I'll let it go the way you played it. Probably will make a pretty good scan at that."

The small woman beamed with relief, punched my shoulder lightly in false camaraderie, and hurried away. I reached down to gather my own clothes, and walked back out toward the set to find myself a shower someplace. As I looked, I found myself whistling.

Oh, sure, I had a right to be pissed. But then again, I had money coming in and a bit of a future in a pretty lucrative business. Screaming and pounding my chest would just send me back to the two-bit scan studios that I'd fought like a sonuvabitch to escape.

Like Mama said, as long as you ain't hurtin' anybody, you just do what you have to do.

Contributors

Renee M. Charles lives in a houseful of cats, has a B.S. in English and also teaches writing. She has been published in over 45 genre magazines and anthologies (including *Weird Tales, Twilight Zone, 2AM* and others) with over 100 stories poems and articles published overall. Some of her major influences include Ray Bradbury, Theodore Sturgeon, Fredric Brown and Dean Koontz. Her story "Cinnamon Roses," originally published by Circlet Press in the anthology B*lood Kiss: Vampire Erotica,* was chosen by Susie Bright for the 1995 *Best American Erotica* and received honorable mention in *Year's Best Fantasy and Horror* edited by Terri Windling and Ellen Datlow.

M. Christian lives, works and plays in San Francisco (and is most of what that implies). He is proud to consider himself a literary streetwalker with a heart of gold. As such, he can be many things to many people—but that costs extra. Known whereabouts: *Best American Erotica 1994, Future Sex, Noirotica* (edited by Thomas S. Roche), *Slippery When Wet, Black Sheets, The Box,* and *Wired Hard Vol. 2* (edited by Cecila Tan, forthcoming in 1996 from Circlet Press). PS: He is also System 7 savvy.

Melanie Miller Fletcher was born and raised in Chicago, and still pines for deep dish pizza. A member of the Starfleet Ladies Auxiliary and Embroidery/Baking Society, she can usually be found somewhere on the Internet, and is currently working on her first novel, *Deus Ex.*

Evan Hollander is a prolific Canadian writer who has published dozens of erotic short stories in a variety of mass-market men's magazines and anthologies. His work

has appeared in such publications as *Gent, 40+,* and *Sugah,* as well as in the Circlet Press anthologies *TechnoSex: Cyber Age Erotica, Of Princes and Beauties.* His first collection of short stories, *Virtual Girls,* has just been published (Circlet Press, 1995).

Jim Lee has published a variety of work in a bewildering assortment of markets since 1982, when an erotic sf poem was chosen for Millea Kenin's *Aliens and Lovers* anthology. Recent publications include fiction in *Aberrations, Hardboiled, Fantastic Collectibles, Hustler Fantasies,* and Volume 3 of Tal Publications' *Bizarre Sex* series.

Yvonne Navarro's fiction has appeared in small pres and professional anthologies since 1984. Her first novel, *AfterAge,* was published in 1993. Her novelization of the MGM science fiction film Species appears in 1995, and her second novel, *deadrush,* appears in October 1995. She is currently working on the novelization of *Aliens: Music of the Spears.*

Thomas S. Roche has appeared in *Black Sheets, Paramour, The Ninth Wave,* and *Slippery When Wet,* as well as the anthologies *Truth Until Paradox, City of Darkness: Unseen,* and *By Her Subdued.* Upcoming appearances include short stories in the anthologies *Dark Angels, Ritual Sex, Backstage Passes,* and *Blood Muse.* He recently edited *Noirotica,* an anthology of erotic crime stories for Masquerade Books (New York). "Temporary Insanity" first appeared in *Black Sheets,* Issue #4, 1994.

Dave Smeds is the author of the novels *The Sorcery Within* and *The Schemes of Dragons* as well as many short stories that have appeared in *Asimov's, The Magazine of Fantasy and Science Fiction,* and *Full Spectrum.* as well as the Circlet Press anthology *TechnoSex: Cyber Age Erotica.* He has sold over three dozens work sof erotic fiction to *Club*

International, Hot Talk, Penthouse Forum, Club Mayfair, and *Lui.*

Doug Tierney is a technical writer and engineer who lives in Boston with his Black Irish girlfriend, two ferrets, and a really stupid cat named Ludicrous. This is his first published work of fiction.

Jarrett Trane claims lineage from the personal body-guards of Swedish elf kings and insists that his employment background includes pyrotechnics (professional fireworks displays) and international law enforcement for an obscure federal agency.

Cecilia Tan, editor, founded Circlet Press in 1992 to publish works of erotic science fiction. Her own fiction has appeared in numerous magazines (Penthouse, Taste of Latex, Paramour, etc.) and anthologies (Looking for Mr. Preston, Herotica 3 and 4, On A Bed of Rice: An Asian American Erotic Feast, By Her Subdued, etc.), not to mention various essays and articles on sex and sexuality here and there. In addition to several upcoming anthologies from Circlet Press, she has also edited a collection of erotic S/M fiction entitled S/M Visions (Masquerade Books, forthcoming October 1995) and is at work on many other projects.

Lee Seed, cover artist, has produced many fine, award-winning illustrations for science fiction/fantasy magazines and for sale at convention art shows. Her work also graces the cover of *Virtual Girls: The Erotic Gems of Evan Hollander* (Circlet Press, Boston). Commissions are welcome.

If you enjoyed **Selling Venus,** you may want to try some other selections published by Circlet Press....

Virtual Girls: The Erotic Gems of Evan Hollander, $6.95

The first collection of fantastic, futuristic erotic tales by talented writer Evan Hollander. Hollander's sexual science fiction expores the erotic frontier with gusto and humor. "Virtual Girls is T&A with G-force!" says Kyle Stone, author of *The Initiation of P.B. 500.*

TechnoSex, edited by Cecilia Tan, $7.95

High technology makes the erotic action better and hotter than ever in these stories by Evan Hollander, Dave Smeds, Elf Sternberg, Nikolai Kingsley, Wendy Rathbone and more. "A seamless blending of modern technology and good old-fashioned smut... The overall intelligence and grace of the writing is remarkable; it is so often lacking in this kind of literature."—*Paramour: Literary and Artistic Erotica.*

SexMagick, edited by Cecilia Tan, $7.95

Women authors conjure up erotic fiction of the hottest kind, from dream-like pagan sex rituals to the sexual blessing of an ancient Mayan god, where magic is real and sex is the power that makes it work.

Our catalog contains dozens of titles of erotic science fiction as well as graphic novels, photography books, S/M how-to books, erotic biographies, and more. Send a SASE for the complete catalog, or request one with your book order! To mail order, send check or money order with $2 postage and handling per book to:

<div align="center">

Circlet Press
PO Box 15143
Boston, MA 02215
circlet-info @ circlet.com
World Wide Web: http://www.circlet.com/circlet/home.html

</div>